PAISLEY

A Visual Survey of Pattern and Color Variations

Tina Skinner

Schiffer Publishing Ltd

4880 Lower Valley Road, Atglen, PA 19310 USA

Acknowledgments

The author is eternally indebted to Tammy Ward,
a dauntlessly fast and incredibly efficient helper.

Copyright © 1998 by Schiffer Publishing Ltd.
Library of Congress Catalog Card Number: 98-84042

Designed by Bruce Waters
Typeset in:Geometric 231 Hv BT / Times Roman

ISBN: 0-7643-0546-8
Printed in China

Published by Schiffer Publishing Ltd.
4880 Lower Valley Road
Atglen, PA 19310
Phone: (610) 593-1777; Fax: (610) 593-2002
E-mail: schifferbk@aol.com
Please write for a free catalog.
This book may be purchased from the publisher.
Please include $3.95 for shipping.
Try your bookstore first.

We are interested in hearing from authors
with book ideas on related subjects.

In Europe, Schiffer books are distributed by
Bushwood Books
6 Marksbury Avenue
Kew Gardens
Surrey TW9 4JF England
Phone: 44 (0) 181 392-8585; Fax: 44 (0) 181 392-9876
E-mail: Bushwdea.aol.com

Contents

Introduction

An illustrious printmaker once told me that paisley was the original print. Way back in time, when someone first got the idea of printing on cloth or some cave wall, the first "rubber stamp" to come to hand was the hand itself. Curled up in a fist, pressed pinkie side into the dye, and applied to a plain ground, a hand leaves the familiar curved teardrop mark we've all come to love.

Though the origin of this shape is not so clear cut, its enduring appeal is. From whatever humble beginnings it may have come, paisley has been showered with flowers, gilded, bejeweled, and adorned with elaborate scroll work by artists. Thus adorned, paisley has charmed everyone, from the most exalted members of royal courts to the humblest of Haight-Ashbury campers.

The annals of paisley history hold that Napoleon Bonaparte introduced this design to the West when he brought a paisley shawl home for his sweet Josephine around 1800. This shawl probably took an artist in India five years to weave, and cost the equivalent of a middle-class home at the time. Thus everyone coveted it. Before long, every lady in the French court had to have one, and the British were not to be outdone.

With such a market, more craftsmen entered into the manufacture of paisley shawls, and one town in Scotland came to base its livelihood upon the production of these required fashion accessories. With widespread distribution and far lower prices, almost every woman in England could own one of these shawls by 1860, and thus the name and fame of that once obscure Scottish hamlet was spread—Paisley.

When bustles hit the fashion scene in 1869, they spelled financial ruin and even famine among the residents of Paisley and India alike. The bustle disrupted the drape of a shawl, and just like that the accessory was packed off for cold storage.

Yet the indelible image of paisley has never quite been put away. It became a household ornament, decorating chintz fabrics manufactured for curtains and upholstery through the turn of the century and on up to the current day. And it saw its greatest revival in the counter culture movement of the 1960s. Paisley's yin or yang shape appealed to those seeking insight from overseas, like The Beatles, a rock group whose members visited Indian gurus. At this time, people were attempting to associate with ethnic cultures in every aspect of their lives, from their clothing and household decorations, to their music and hand-painted Volkswagens.

Paisley's strongest appeal, however, lies in its versatility. It draws artists, challenging them with its traditional adornment and its ability to soak up vivid colors. It fits easily within geometric patterns, and it jumps free of attempts to obscure it by using abstract and impressionist techniques.

This book attempts to show the many facets of the paisley form, from its traditional roots in floral prints, to its modernistic applications. Hundreds of fabric swatches are displayed herein. These are identified, when possible, by content and country and year of origin. It is an invaluable reference guide for artists and designers, with a fascinating study in the back of several patterns with dozens of color variations. It is hoped that this book will stimulate readers to create new paisley patterns, joining a long line of artists that may well extend back to the stone ages.

Chapter 1

Evolved from Plant Forms

Among the many theories about paisley's origin is the idea that the shape grew from stylized representations of flowers, leaves, stems, and bulbous root systems. Such floral patterns were common on shawls woven in seventeenth and eighteenth century India.

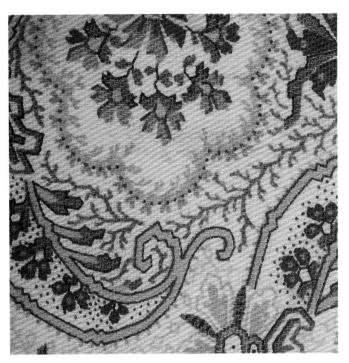

United States, 1940s.

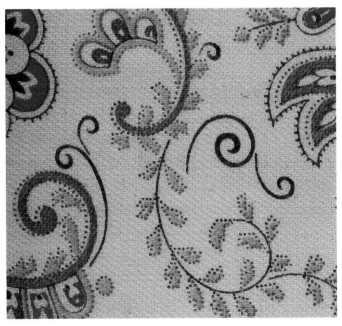

United States, 1940s.

United States, 1940s.

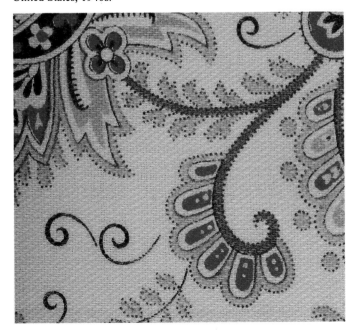

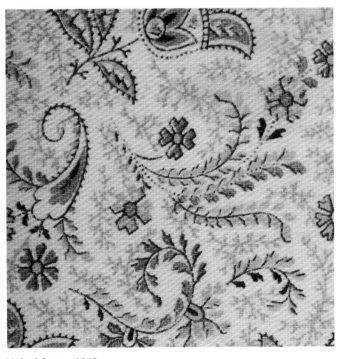

United States, 1940s.

Silk. United States, late 1950s.

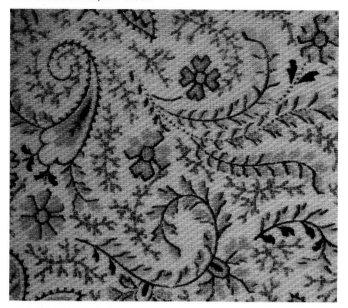

United States, 1950s.

United States, 1940s.

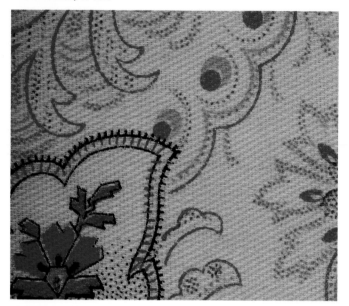

United States, 1950s.

United States, late 1950s.

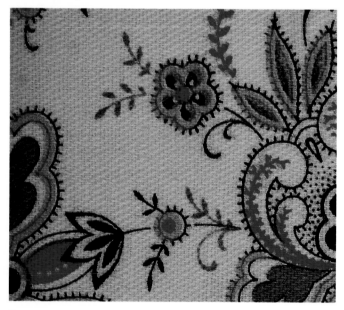

Cotton chintz. United States, 1938.

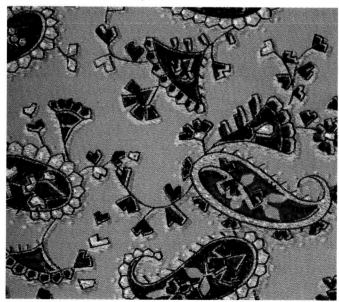

United States, 1950s.

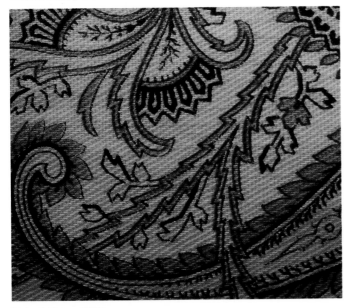

United States, 1950s.

United States, 1950s.

France, 1960s.

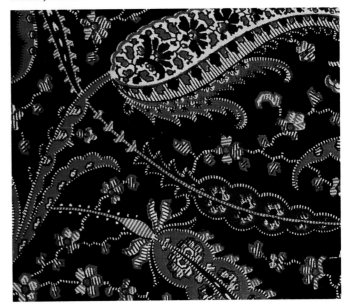

United States, 1950s.

France, 1964.

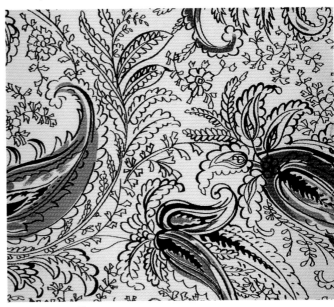

United States, 1950s.

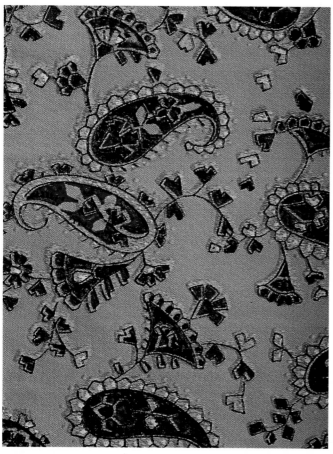

United States, 1950s.

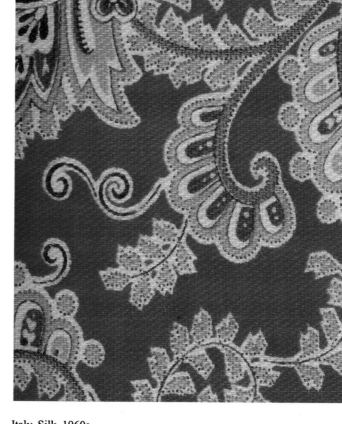

Cotton. United States, 1939.

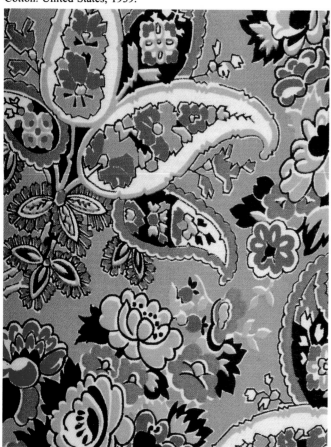

Italy, Silk, 1960s

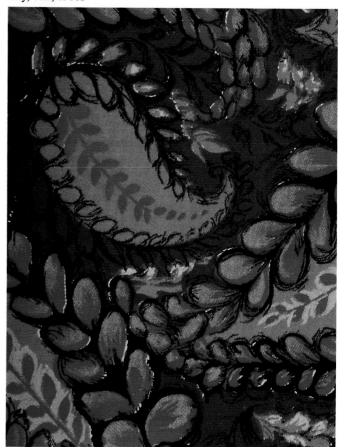

United States, 1950s.

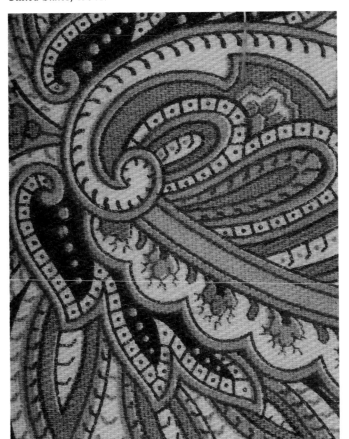

Silk. France, 1960s.

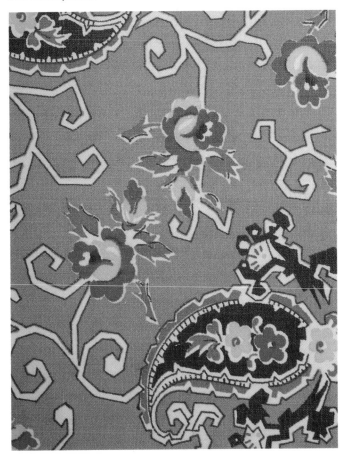

United States, 1940s.

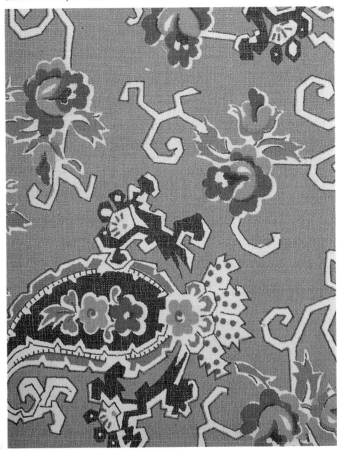

Color variation.

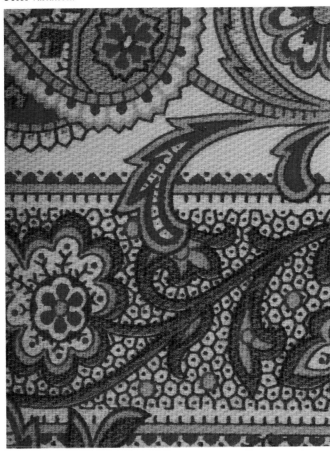

9

Cotton. Italy, 1965.

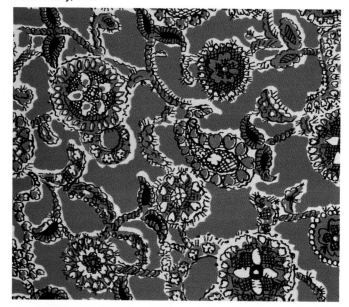

Cotton. Italy, 1965.

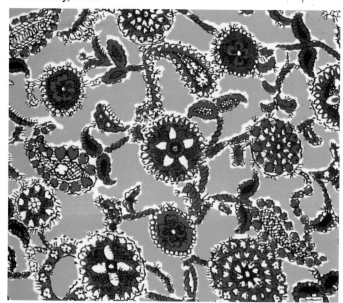

Cotton. Italy, 1965.

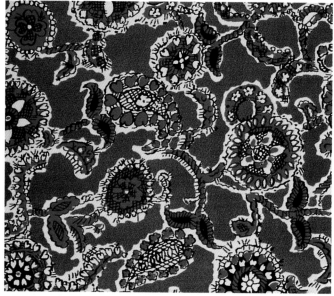

Manmade fibers with metallic threads. France, 1960s.

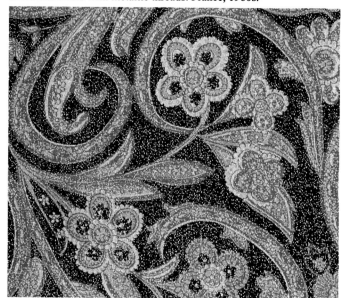

Cotton. Italy, 1965.

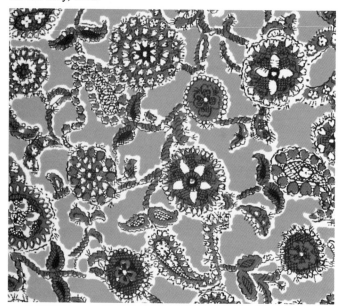

Manmade fibers with metallic threads. France, 1960s.

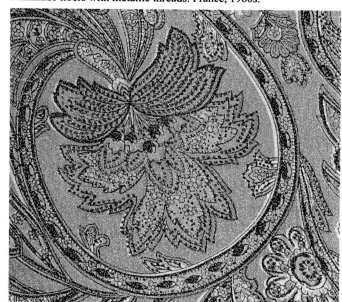

Chapter 2

Elaborate Borders

Paisley patterns were first introduced to European eyes in the form of borders on beautiful, hand-woven shawls from India. Napoleon Bonaparte is credited with gifting his Josephine with one, and before long they were all the rage in the courts of Europe. Cashing in on the fad, the folks in Paisley, Scotland, began the manufacture of such shawls, thus lending a name to the stylized and increasingly elaborate teardrop shape.

Color variations on a pattern for silk scarf border prints.

Color variations on a pattern for silk scarf border prints.

Color variations on a pattern for silk scarf border prints.

Color variations on a pattern for silk scarf border prints.

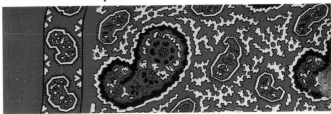

Color variations on a pattern for silk scarf border prints.

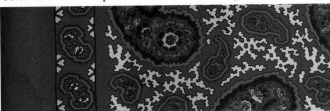

Color variations on a pattern for silk scarf border prints.

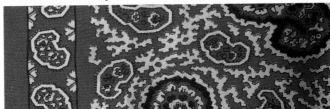

Color variations on a pattern for silk scarf border prints.

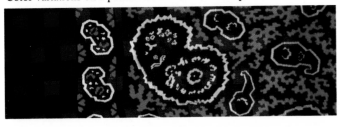

Color variations on a pattern for silk scarf border prints.

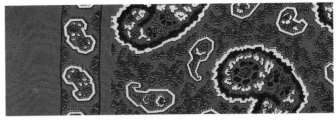

Color variations on a pattern for silk scarf border prints.

Color variations on a pattern for silk scarf border prints.

Color variations on a pattern for silk scarf border prints.

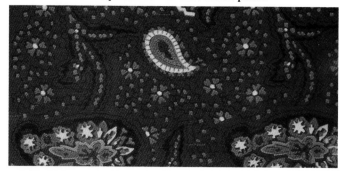

Cotton chintz border print color variations. United States, 1939.

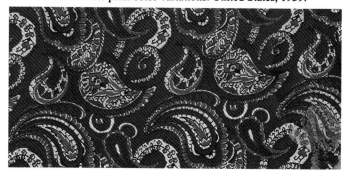

Color variations on a pattern for silk scarf border prints.

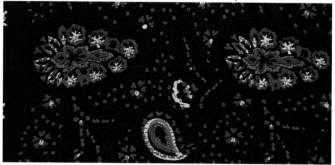

Color variations on a pattern for silk scarf border prints.

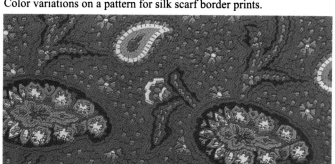

Color variations on a pattern for silk scarf border prints.

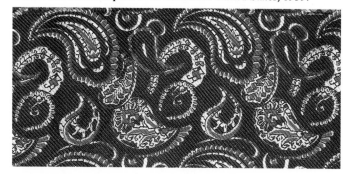

Color variations on a pattern for silk scarf border prints.

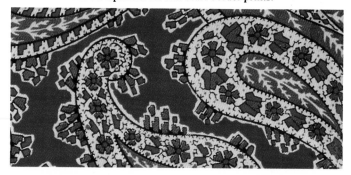

Cotton chintz border print color variations. United States, 1939.

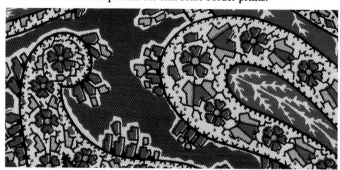

Color variations on a pattern for silk scarf border prints.

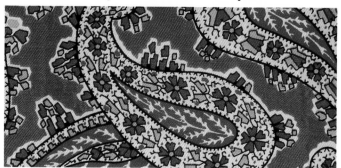

Cotton chintz border print color variations. United States, 1939.

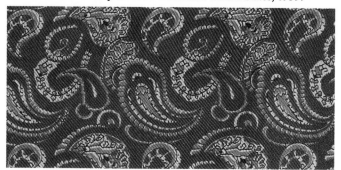

Color variations on a pattern for silk scarf border prints.

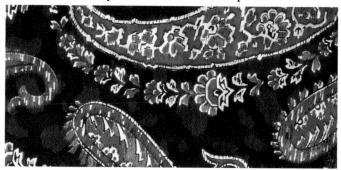

Color variations on a pattern for silk scarf border prints

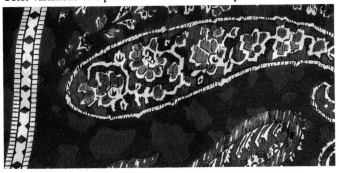

Color variations on a pattern for silk scarf border prints.

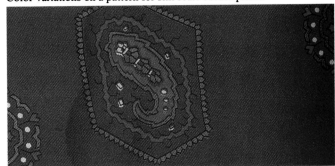

Color variations on a pattern for silk scarf border prints

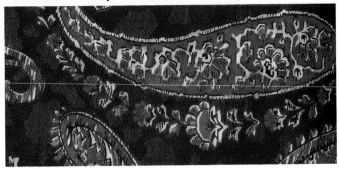

Color variations on a pattern for silk scarf border prints.

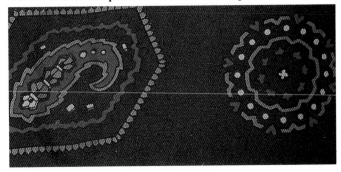

Color variations on a pattern for silk scarf border prints

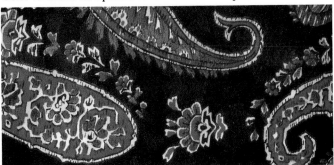

Cotton, color variations on a border pattern.

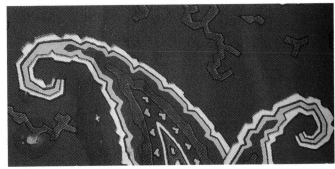

Color variations on a pattern for silk scarf border prints.

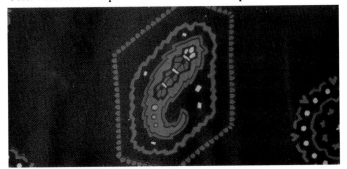

Cotton, color variations on a border pattern.

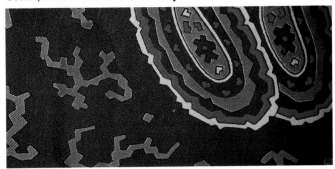

Color variations on a pattern for silk scarf border prints.

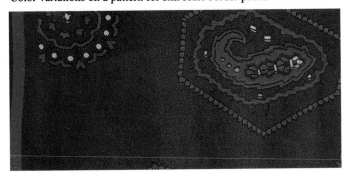

Color variations on a pattern for silk scarf border print.

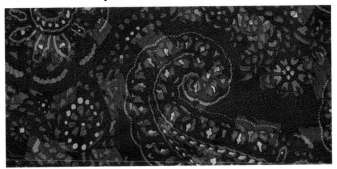

Color variations on a pattern for silk scarf border print.

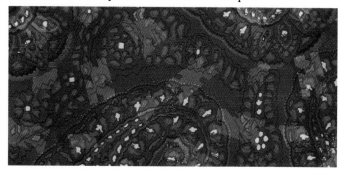

Cotton border print, color variations.

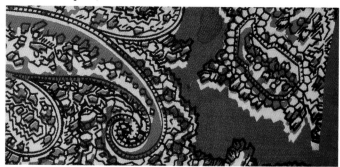

Color variations on a pattern for silk scarf border print.

Cotton border print, color variations.

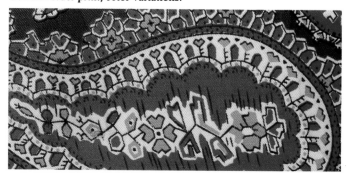

Color variations on a pattern for silk scarf border print.

Cotton border print.

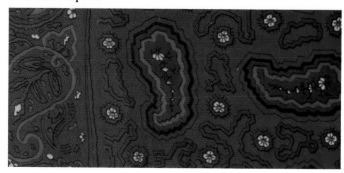

Cotton border print, color variations.

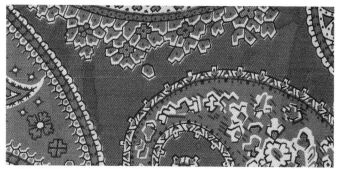

Cotton border print.

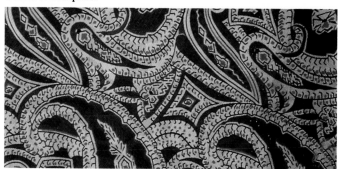

Cotton border print, color variations.

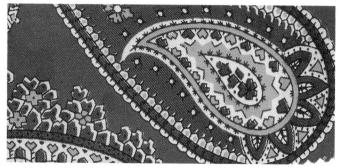

Cotton border print.

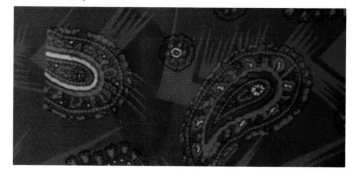

1 4

Cotton border print.

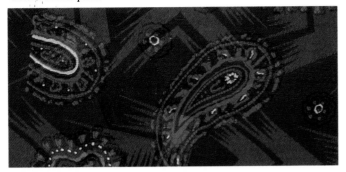

Manmade fibers. France, 1960s.

Cotton border print, color variations. United States, 1950s.

Manmade fibers. France, 1960s.

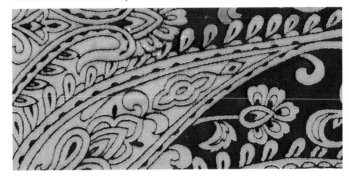

Cotton border print, color variations. United States, 1950s.

Cotton. United States, 1950s.

Cotton border print, color variations. United States, 1950s.

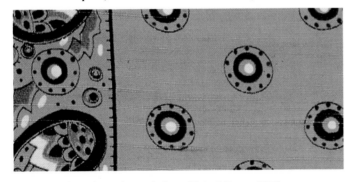

Cotton. United States, 1950s.

Cotton border print, color variations. United States, 1950s.

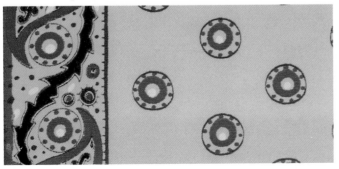

Allover

Allover paisley patterns characterize the genre. Elaborate decorations and backgrounds for the characteristic shape evoke a rich, exotic image, which was popular in home furnishings during the 1930s and '40s. Allover patterns invite the use of bold colors, and challenge designers to experiment with endless combinations.

Cotton chintz. United States, 1938.

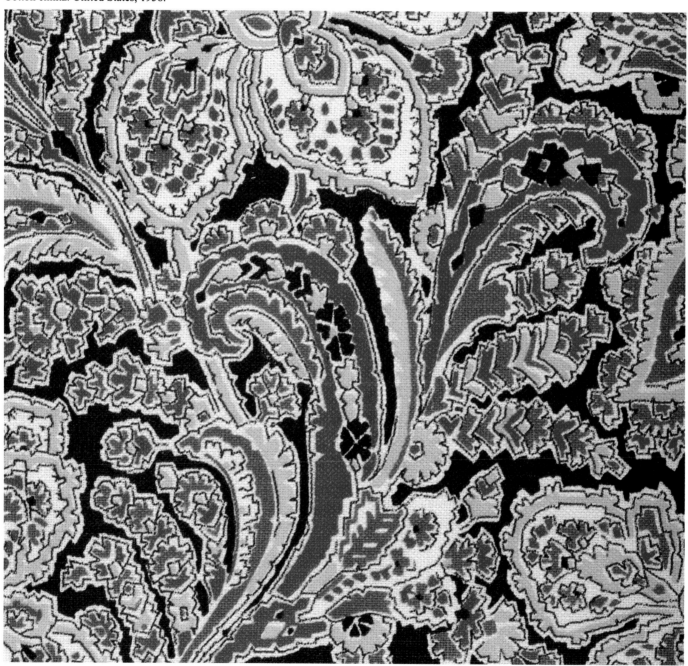

Color variations.

Color variations.

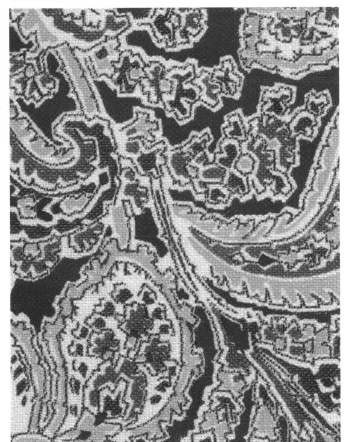

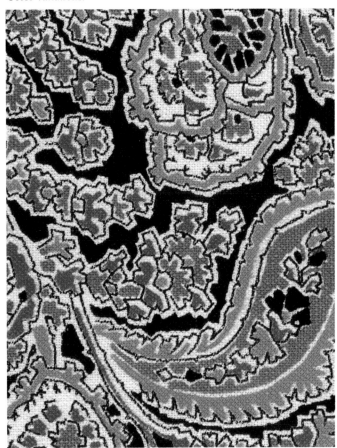

Color variations.

Color variations.

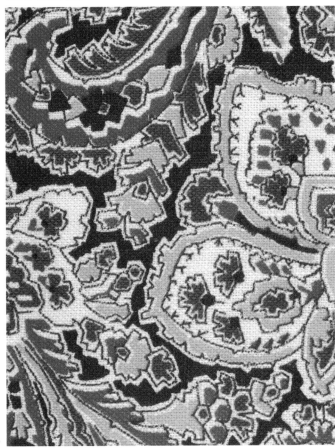

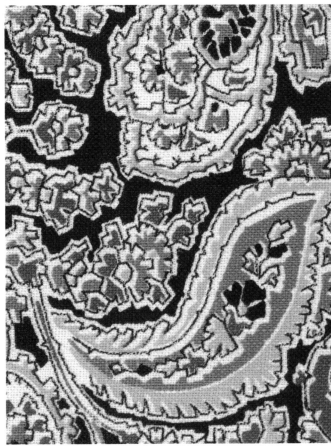

Cotton print color variations. United States, 1939.

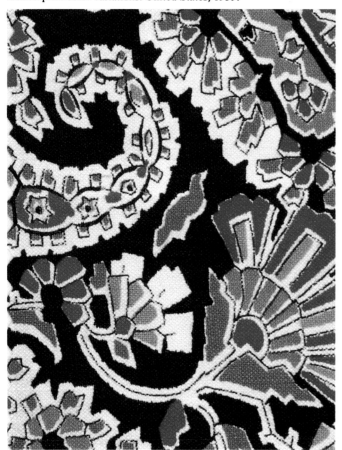

Cotton print color variations. United States, 1939.

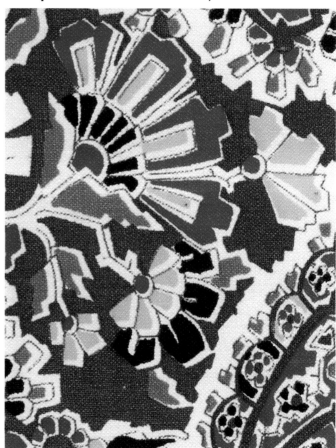

Cotton print color variations. United States, 1939.

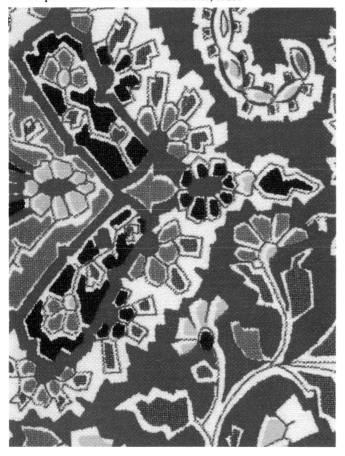

Cotton print color variations. United States, 1939.

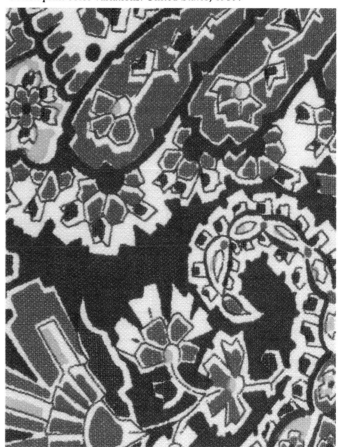

Cotton print color variations. United States, 1939.

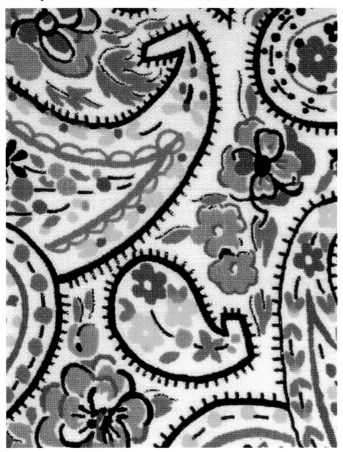

Cotton print color variations. United States, 1939.

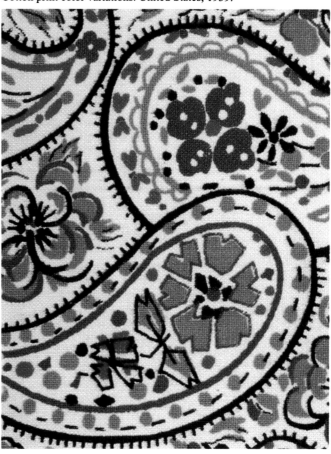

Cotton print color variations. United States, 1939.

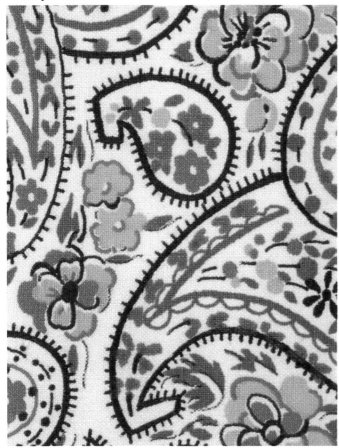

Cotton print color variations. United States, 1939.

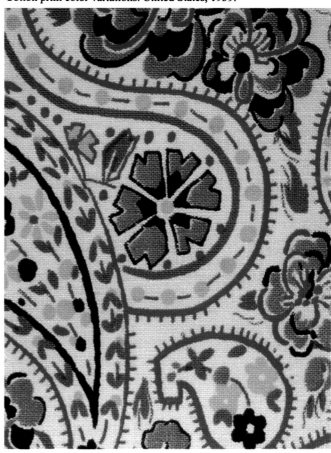

Cotton print color variations. United States, 1939.

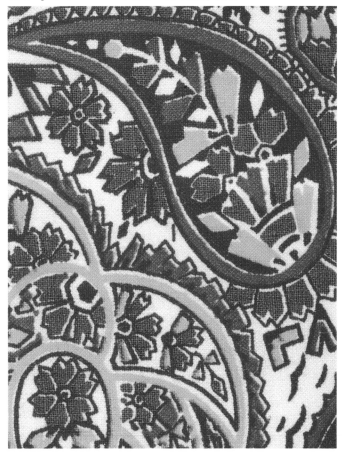

Cotton print color variations. United States, 1939.

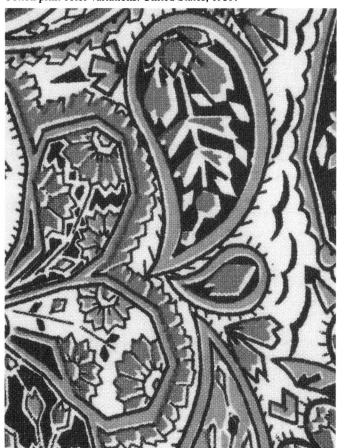

Cotton print color variations. United States, 1939.

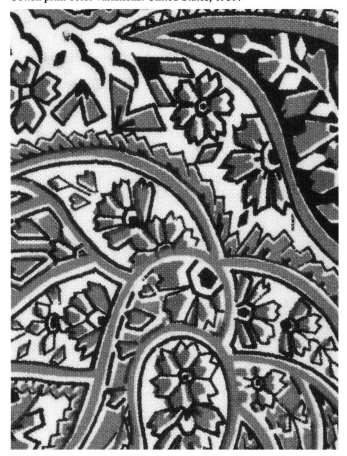

Cotton print color variations. United States, 1939.

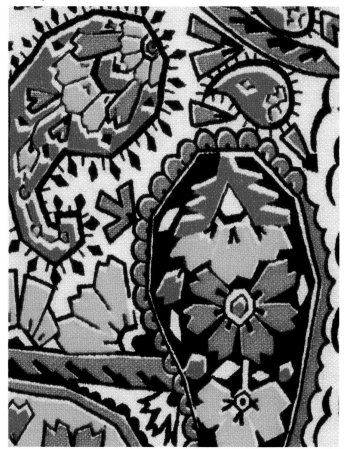

Cotton print color variations. United States, 1939. ⇐

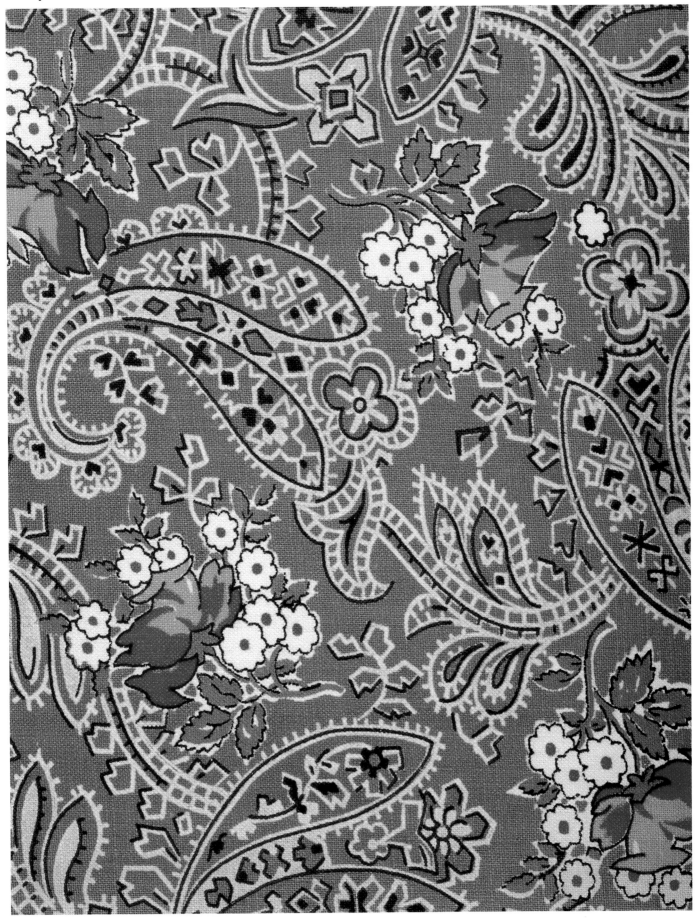

Cotton print color variations. United States, 1939.

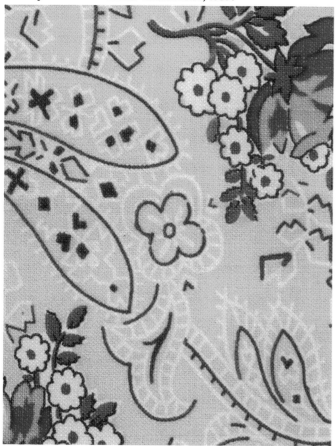

Cotton print color variations. United States, 1939.

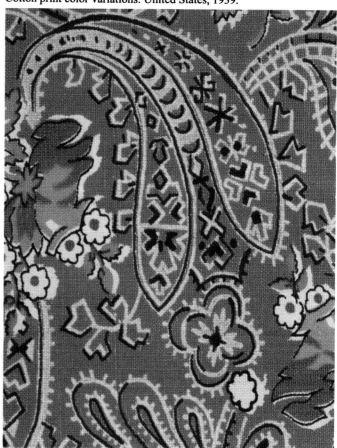

Cotton print color variations. United States, 1939.

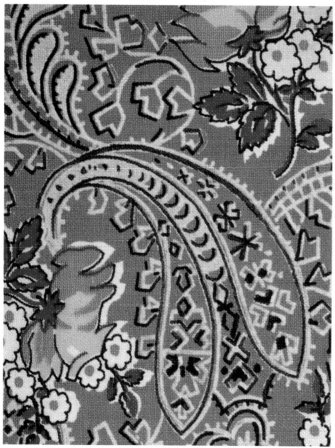

Cotton print color variations. United States, 1939.

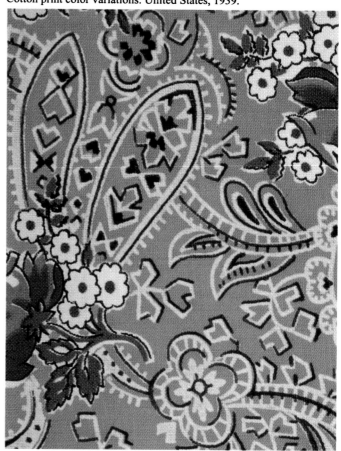

Cotton print color variations. United States, 1939.

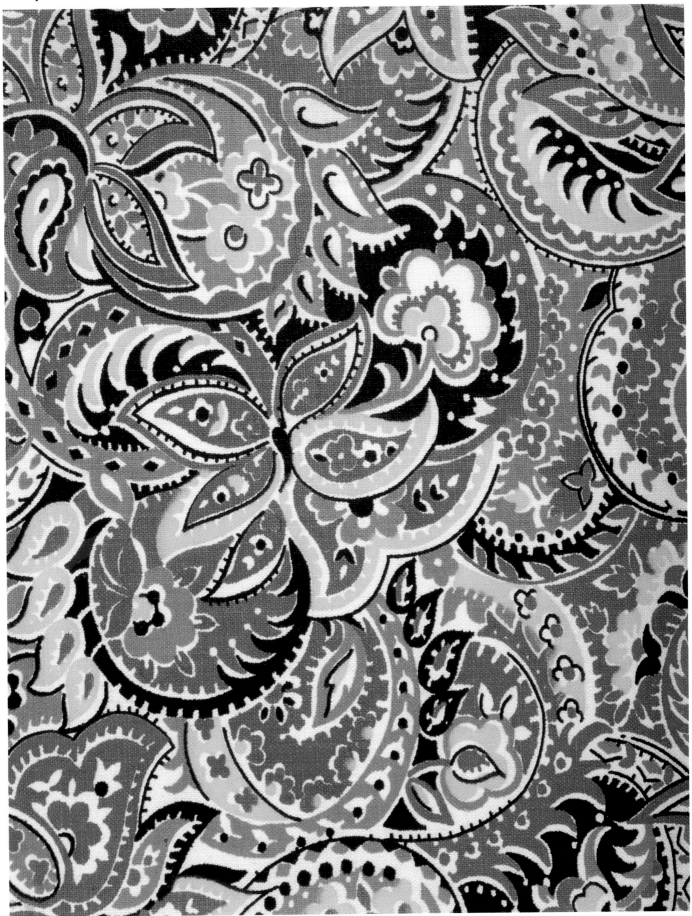

Cotton print color variations. United States, 1939.

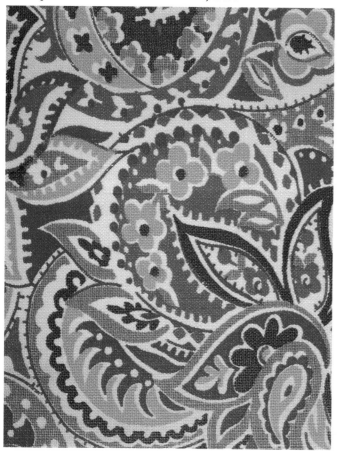

Cotton print color variations. United States, 1939.

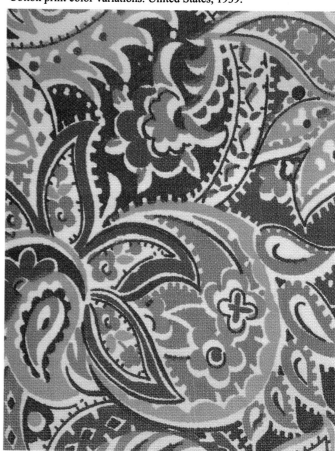

Cotton print color variations. United States, 1939.

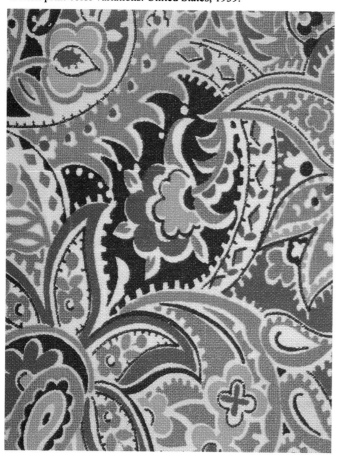

Cotton print color variations. United States, 1939.

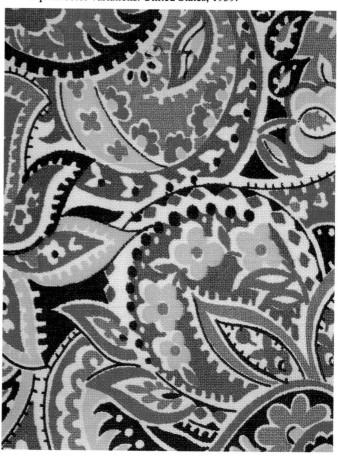

Cotton chintz. United States, 1939.

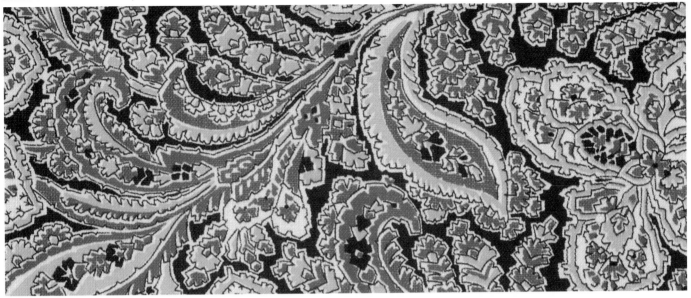

Cotton. United States, 1939.

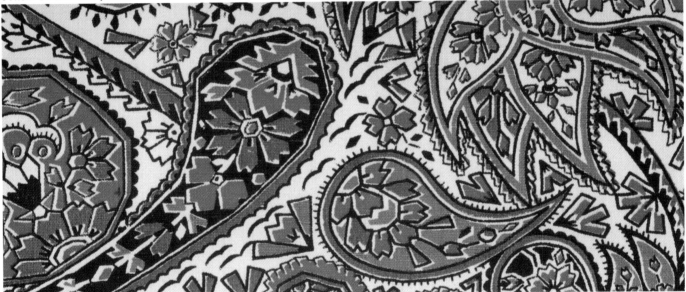

Cotton. United States, 1939.

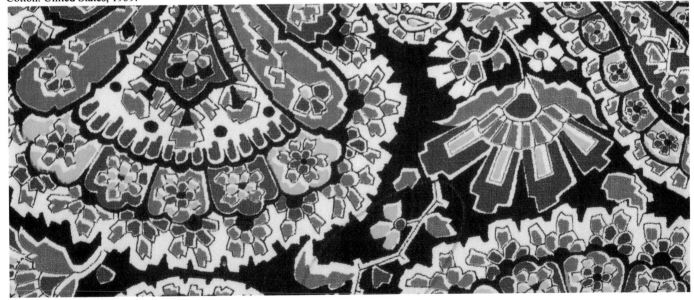

Silk.

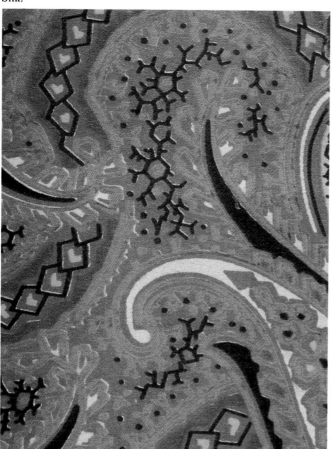

Silk.

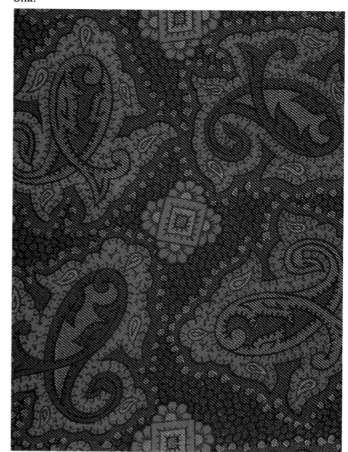

Silk.

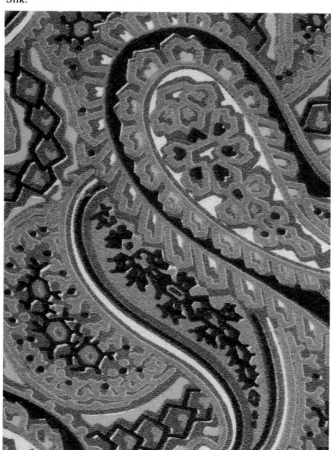

Silk.

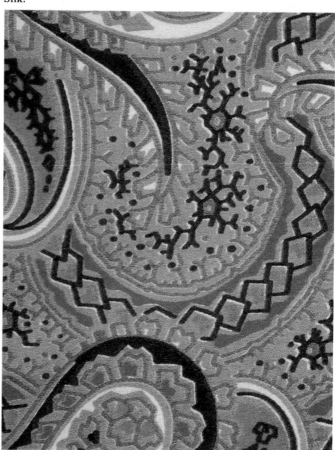

Foulard Patterns

Deriving its name first from lightweight silk fabrics, the French word "foulard" is now more frequently associated with the small patterns that were printed on the handkerchief-weight fabrics. Paisley has been a timeless favorite in foulard patterns, which are most common in men's neckties.

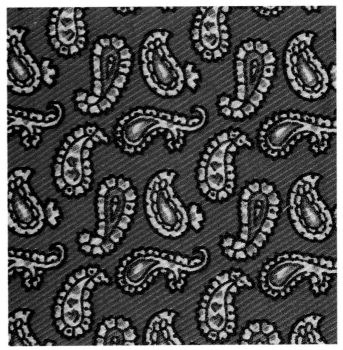

Silk.

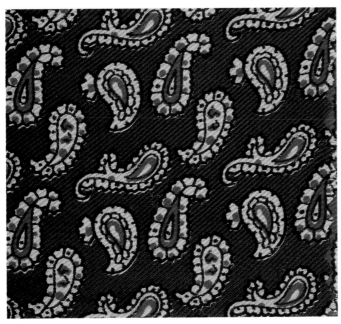

Silk.

Silk.

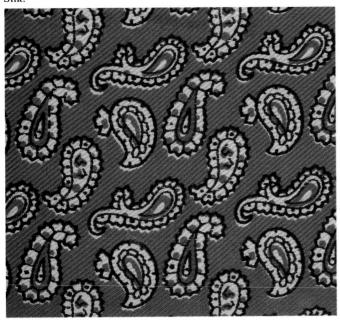

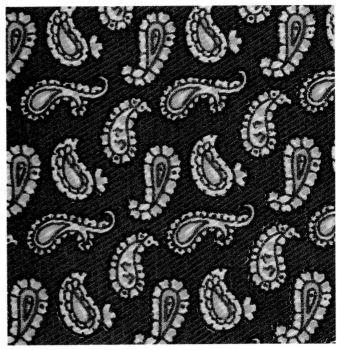

Silk.

Silk. Late 1950s.

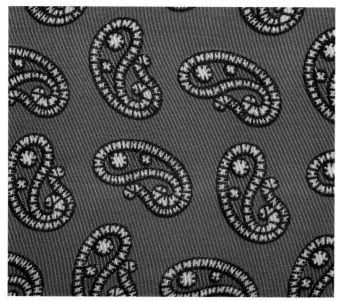

Silk. Late 1950s.

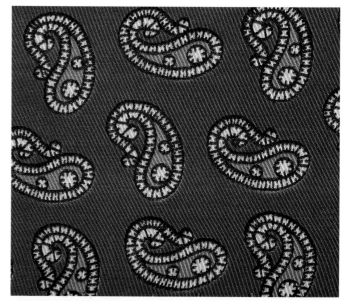

Silk. Late 1950s.

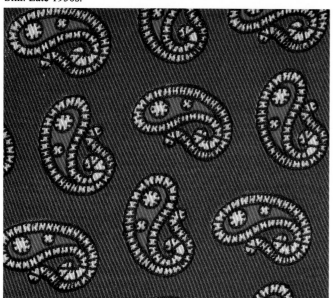

Silk. Late 1950s.

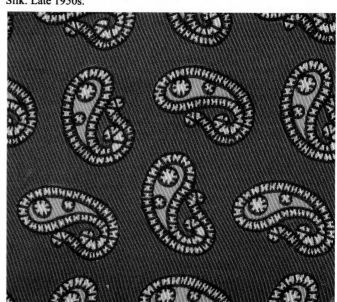

Silk. Late 1950s.

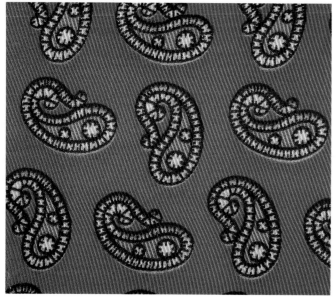

Silk. Late 1950s.

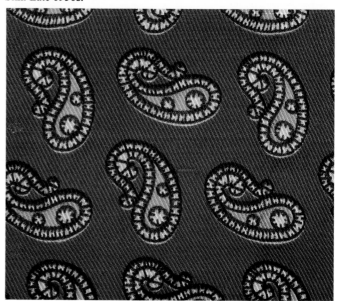

2 8

Silk. 1960s.

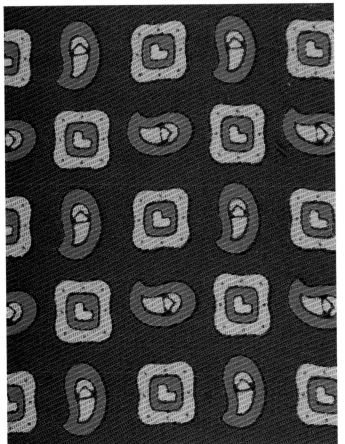

Silk. 1960s.

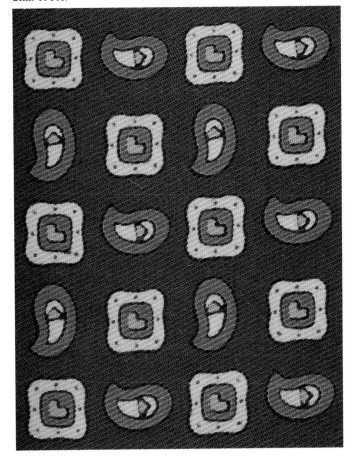

Silk. 1960s.

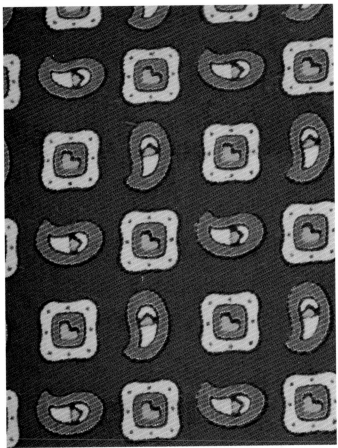

Silk. 1960s.

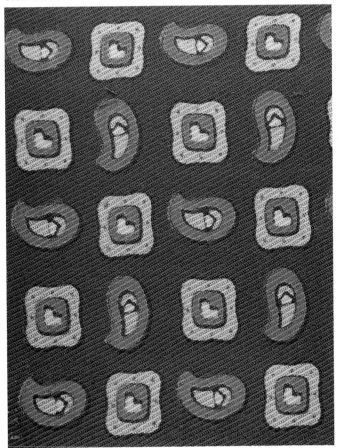

2 9

Silk. 1960s.

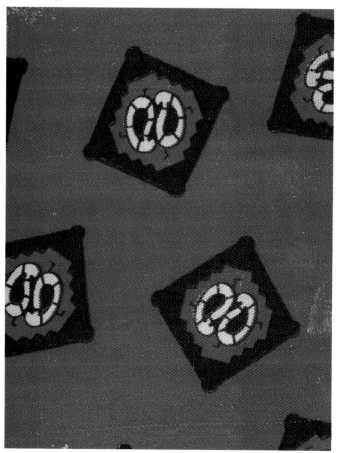

Silk. 1960s.

Silk. 1960s.

Silk. 1960s.

Silk. 1960s.

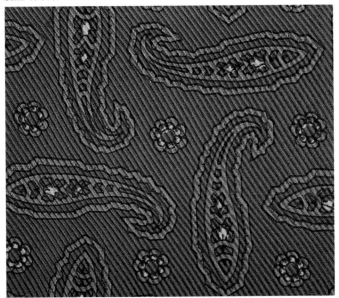

Silk. 1960s.

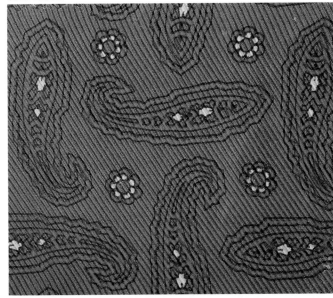

Silk. 1960s.

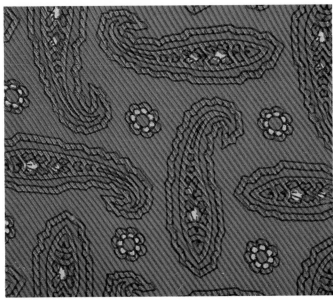

Silk. 1960s.

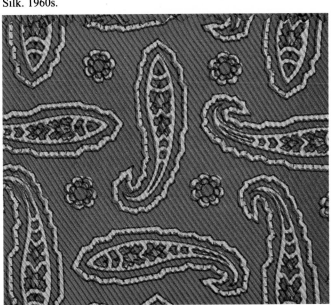

Silk. 1960s.

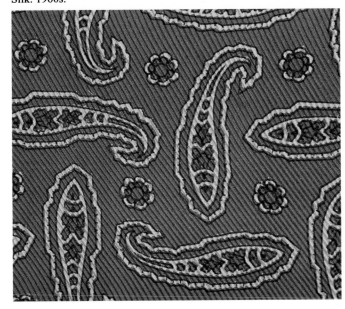

Silk. 1960s.

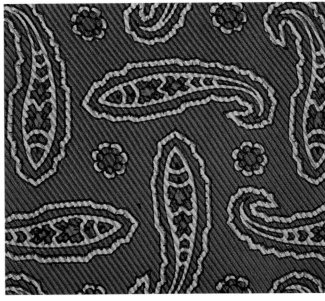

Silk. 1960s.

Silk. 1960s.

Silk. 1960s.

Silk. 1960s.

Silk. 1960s.

Silk. 1960s.

Silk. 1960s.

Silk. 1960s.

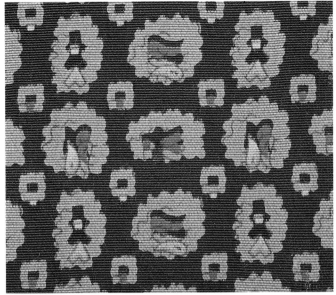

Silk. 1960s.

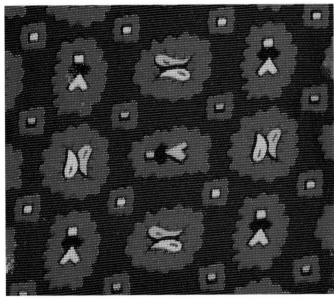

Silk. 1960s.

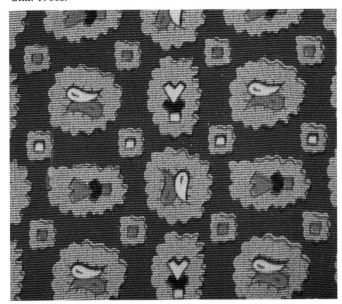

Silk. 1960s.

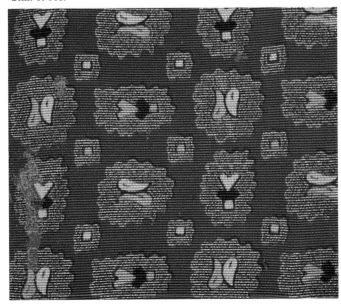

Silk. 1960s.

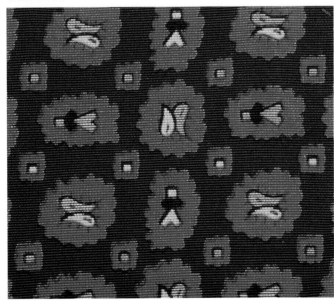

United States, 1939.

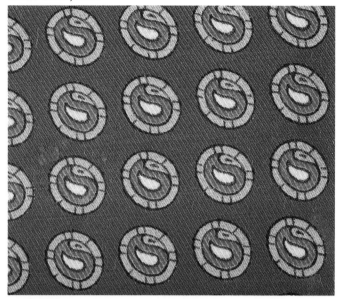

United States, 1939.

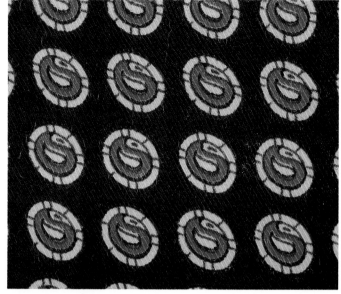

United States, 1939.

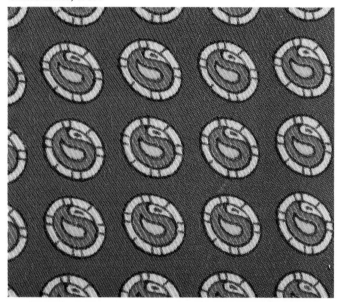

United States, 1939.

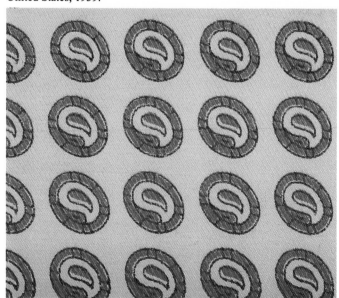

United States, 1939.

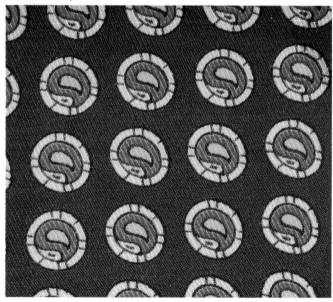

United States, 1939.

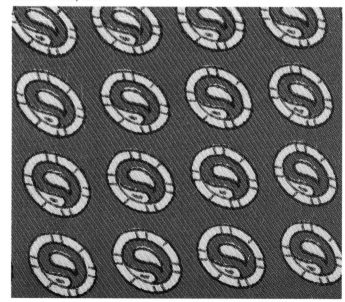

3 4

Silk. Late 1950s.

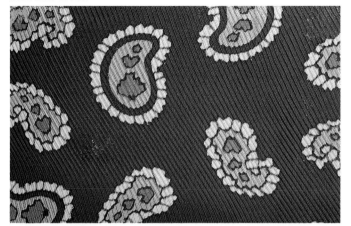

Silk. Late 1950s.

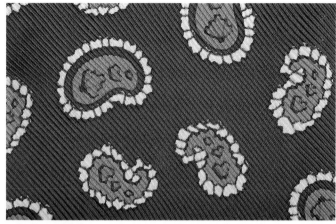

Silk. Late 1950s.

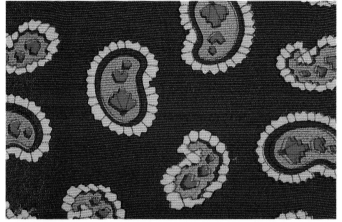

Silk. Late 1950s.

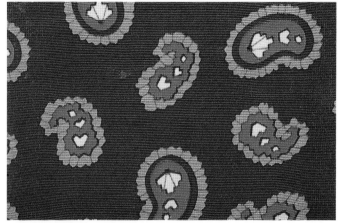

Silk. Late 1950s.

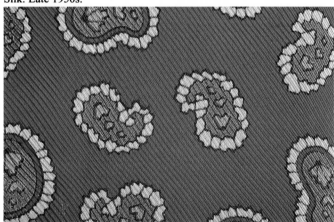

Silk. Late 1950s.

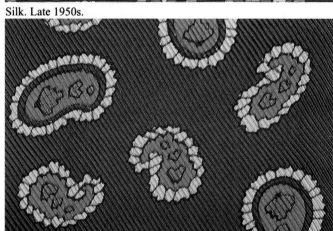

Silk. Late 1950s.

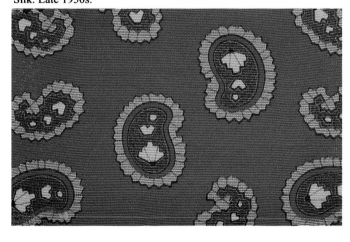

Silk. Late 1950s.

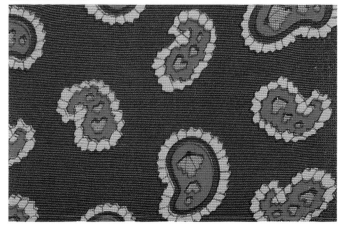

Silk. 1960s.

Silk. 1960s.

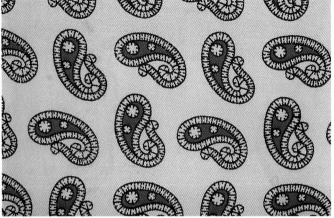

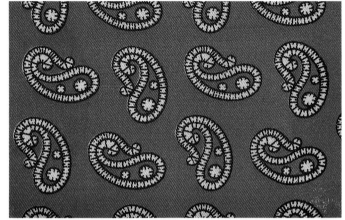

Silk. 1960s.

Silk. 1960s.

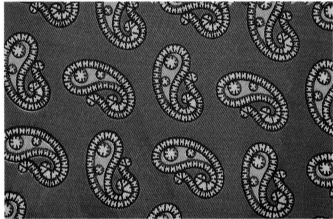

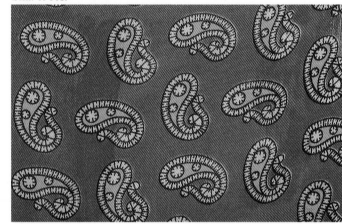

Silk. 1960s.

Silk. 1960s.

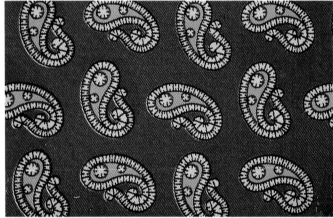

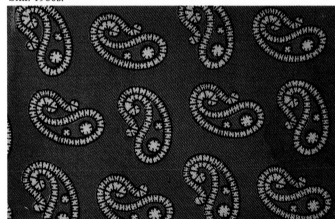

Silk. 1960s.

Silk. 1960s.

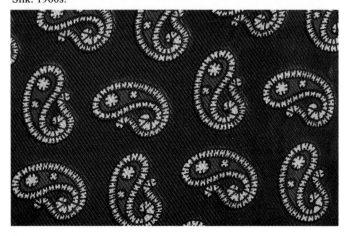

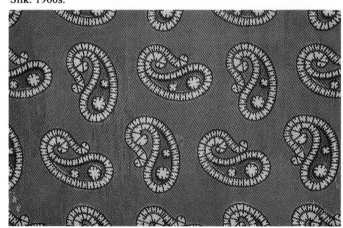

Pattern variations.

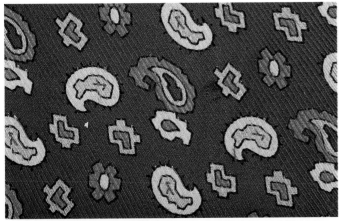

Pattern variations.

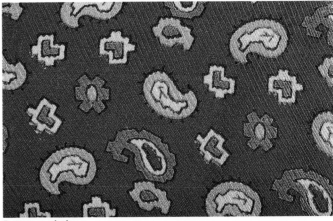

Pattern variations.

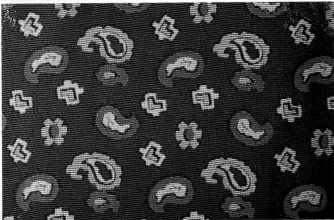

Pattern variations.

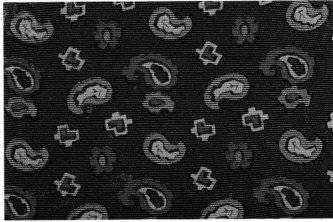

Pattern variations.

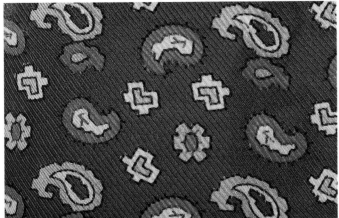

Pattern variations.

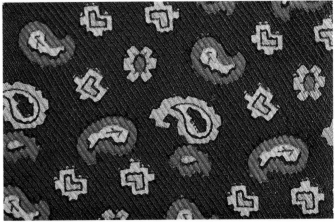

Pattern variations.

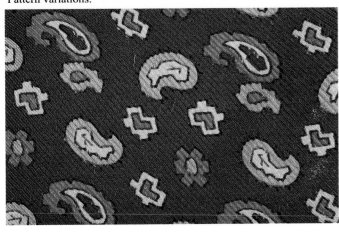

Pattern variations.

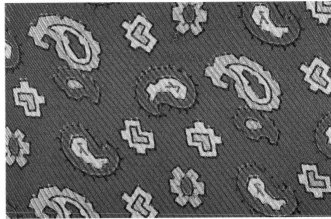

Silk. 1960s.

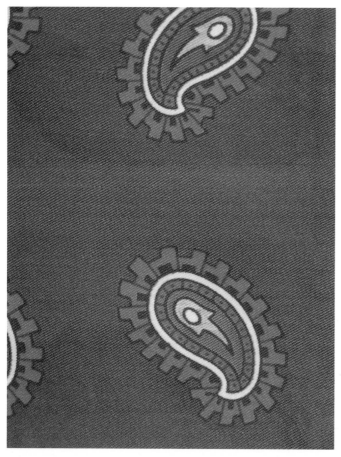

Silk. 1960s.

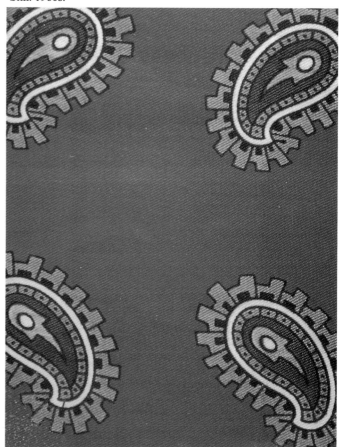

Silk. 1960s.

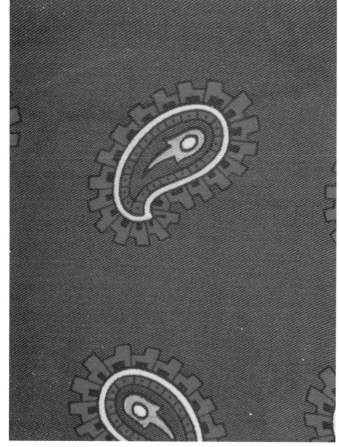

Silk. 1960s.

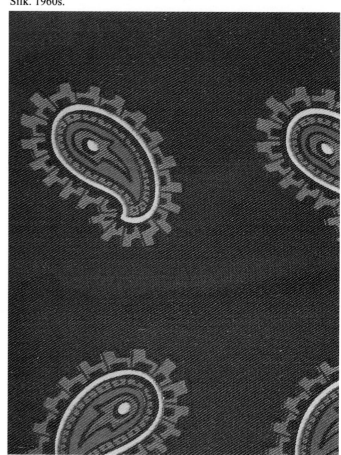

Silk. 1960s.

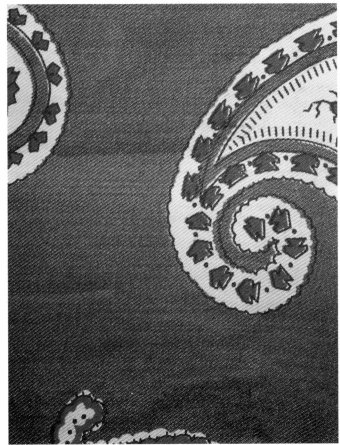

Silk. 1960s.

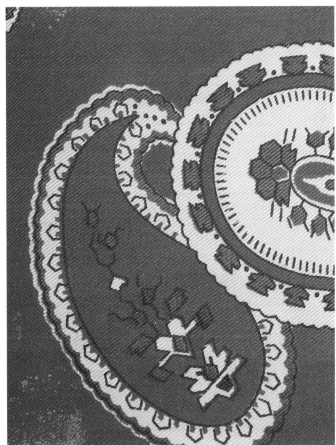

Silk. 1960s.

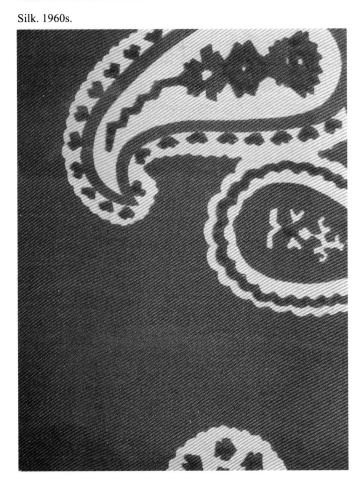

Silk. 1960s.

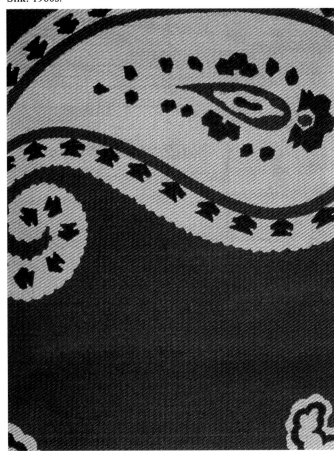

Silk. 1960s.

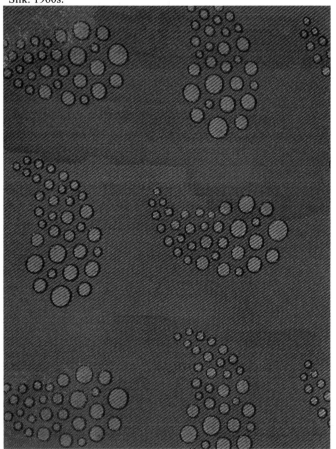

Silk. 1960s.

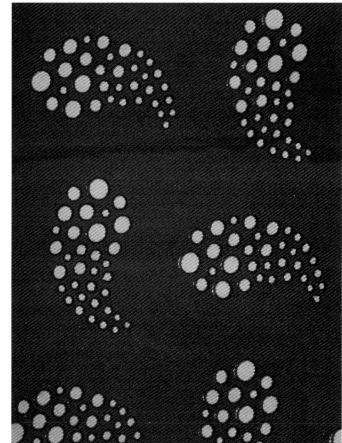

Silk. 1960s.

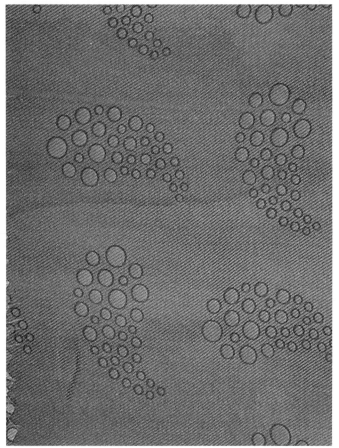

Silk. 1960s.

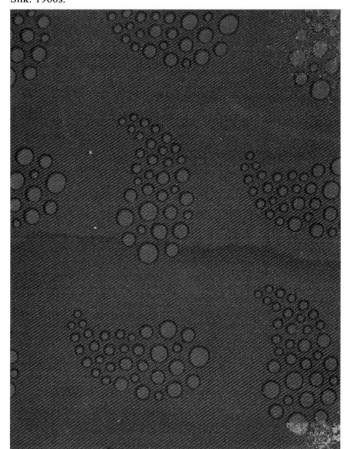

Experiments in Form and Design

A basic, graphic form, paisley has performed as a spring-board for designers seeking creative expression.

Color variations on printed pattern with metallic accents.

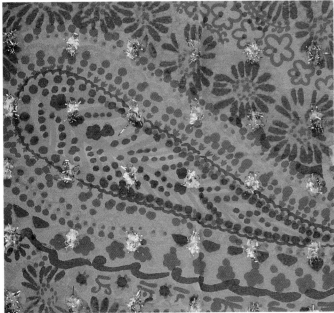

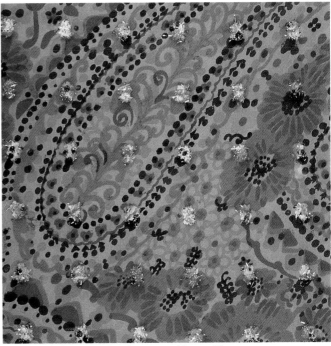

Color variations on printed pattern with metallic accents.

Color variations on printed pattern with metallic accents.

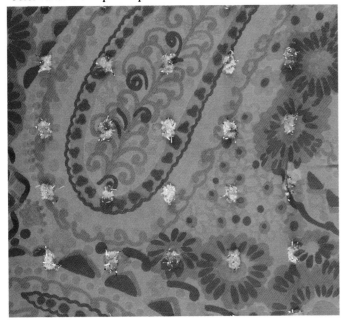

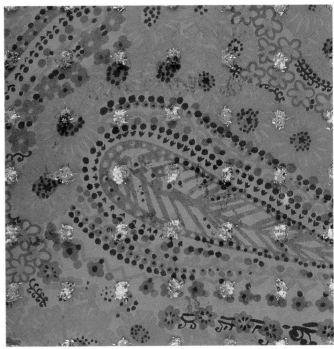

Color variations on printed pattern with metallic accents.

Color variations on woven pattern with metallic accents.

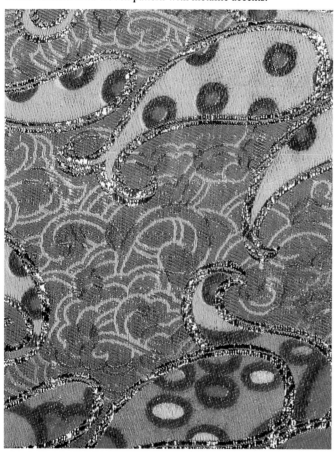

Color variations on woven pattern with metallic accents.

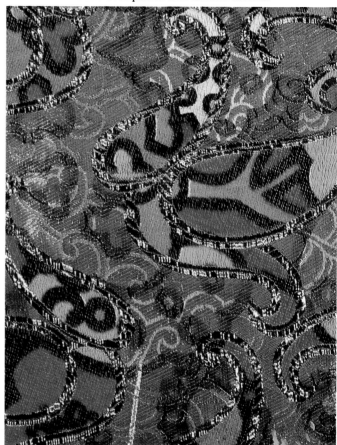

Color variations on woven pattern with metallic accents.

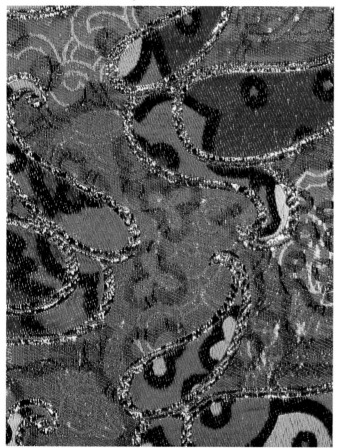

Color variations on woven pattern with metallic accents.

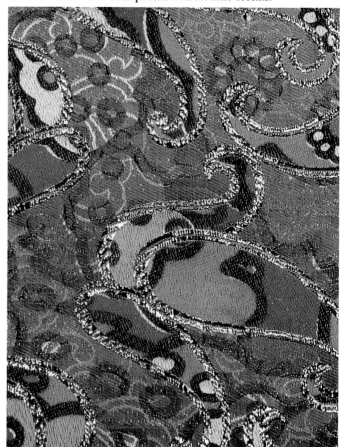

Rayon, 1960s.

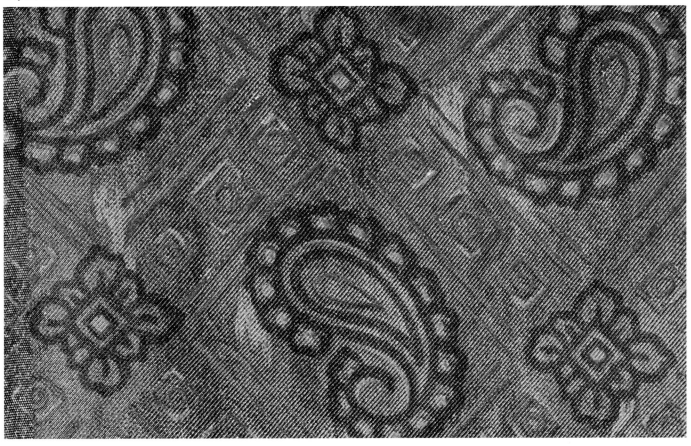

Cotton blend. 1940s.

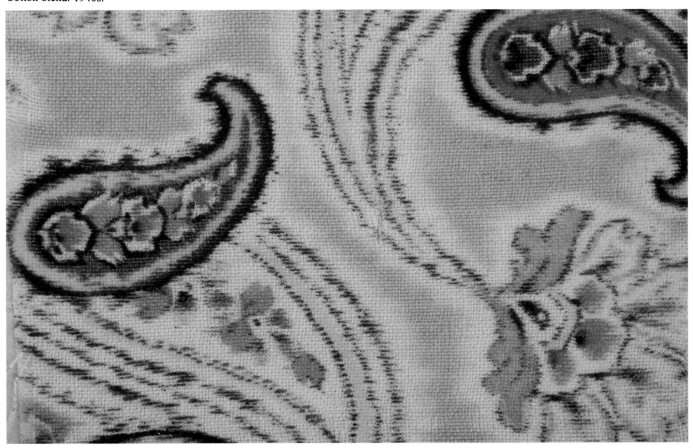

Cotton. United States, 1938.

Italy, 1964.

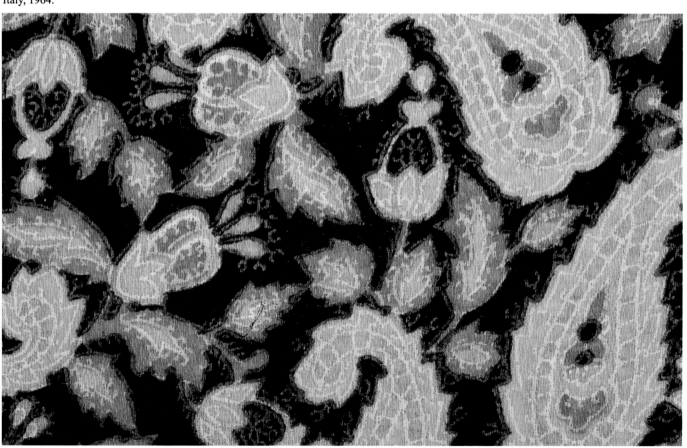

Silk, 1960s.

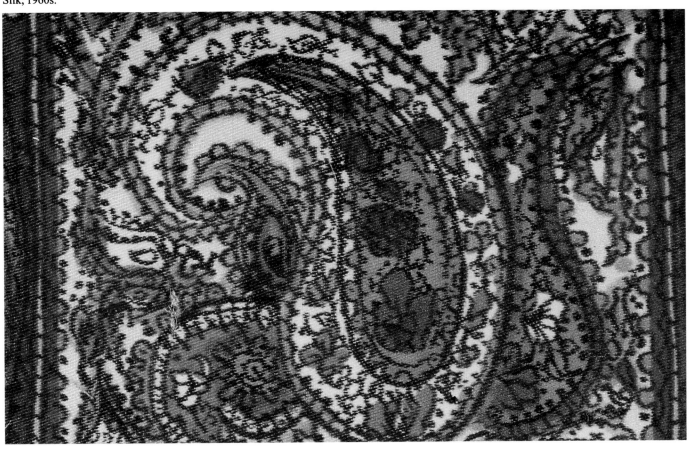

Cotton/rayon, 1960s.

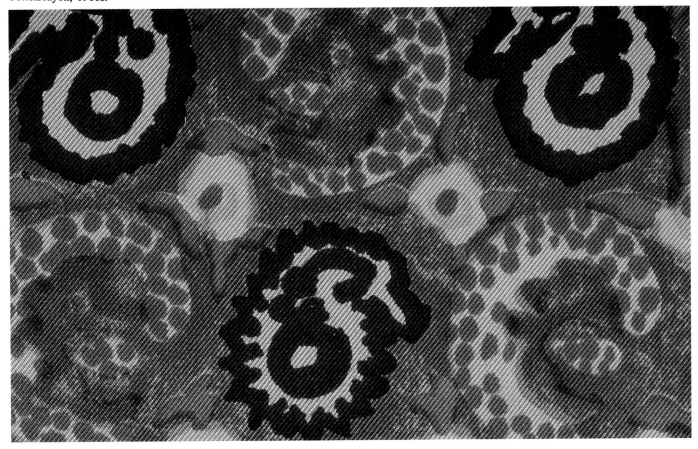

United States, 1950s.

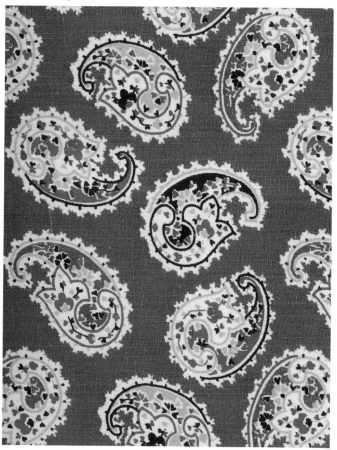

United States, 1950s.

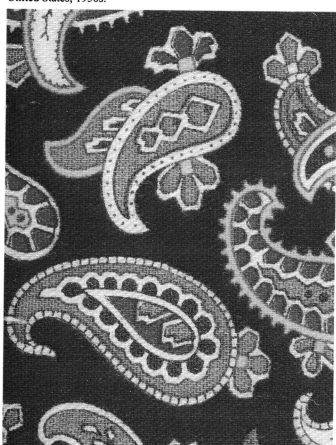

United States, 1950s.

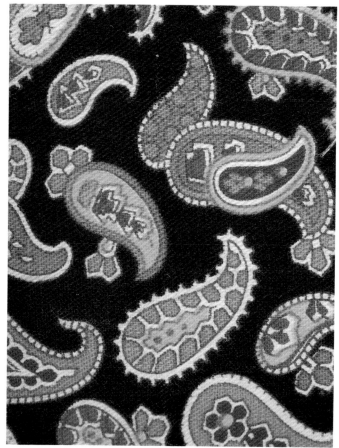

Italy, 1964.

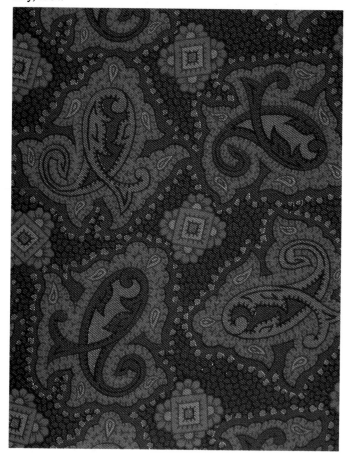

1960s.

1940s.

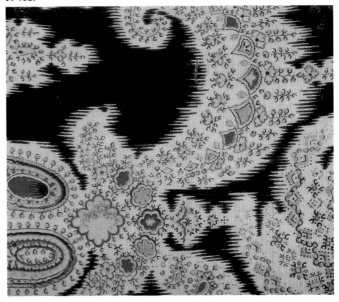

Cotton chintz. United States, 1938.

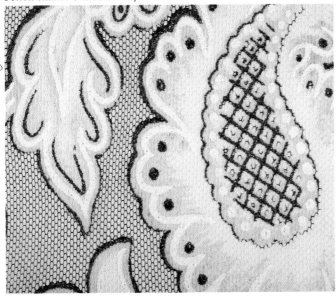

1960s.

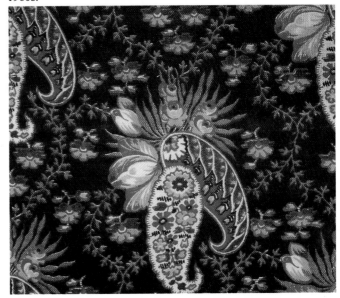

Cotton. United States, 1938.

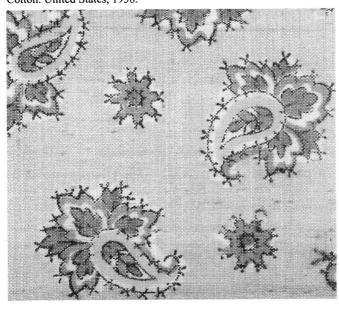

1960s.

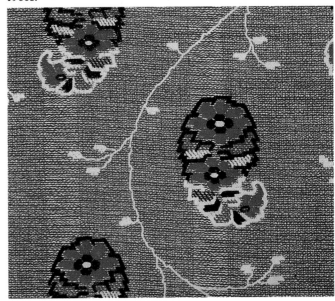

United States, 1949.

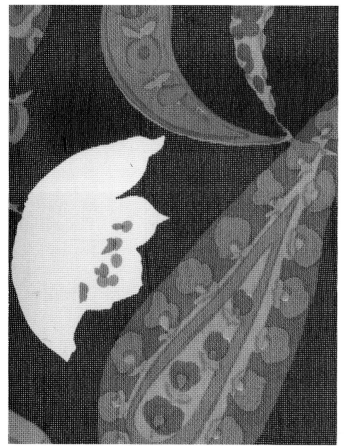

1950s.

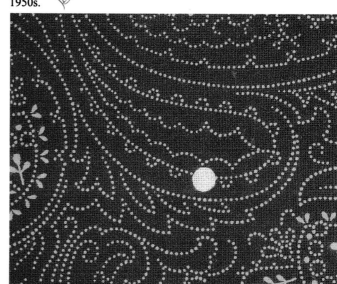

1950s.

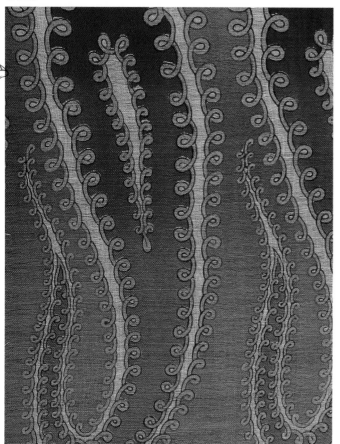

1960s.

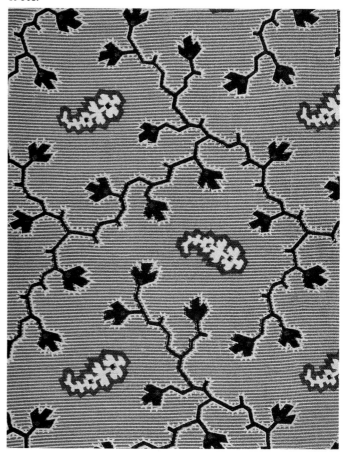

4 8

1950s.

Italy, mid '60s.

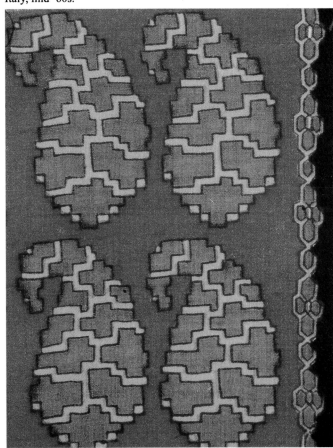

1950s.

Cotton chintz. United States, 1938.

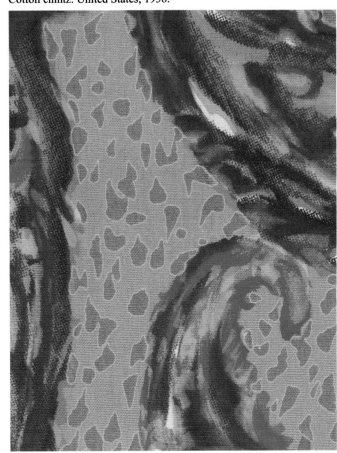

4 9

1950s.

1960s.

1950s.

Silk.

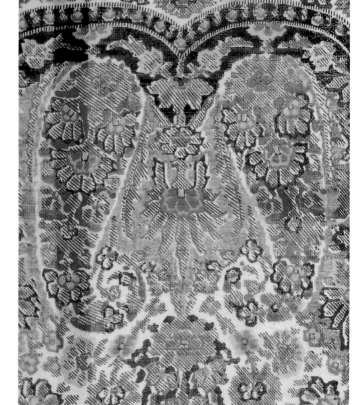

1950s.

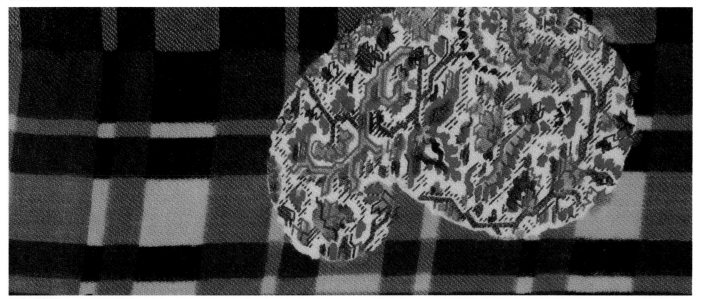

Italy, 1963.

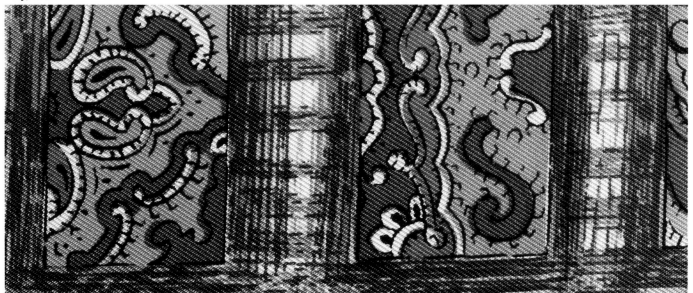

Italy, mid '60s.

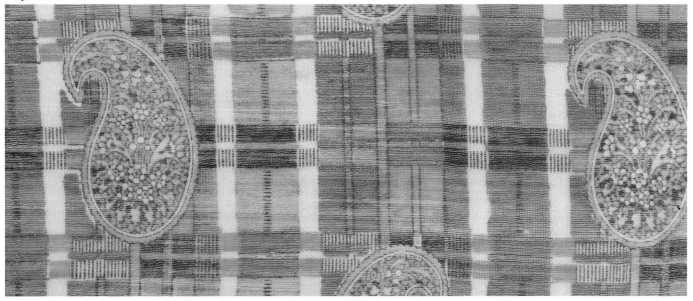

Italy, 1964.Italy, 1964.

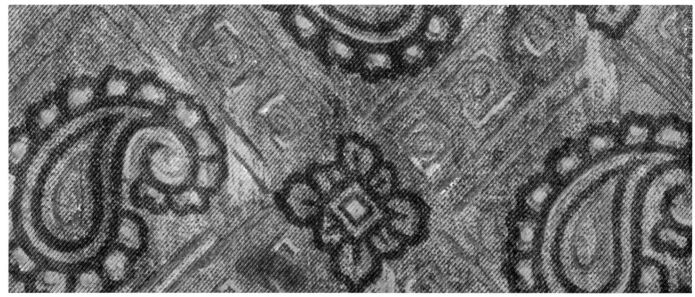

Color variations. 1940s.Color variations. 1940s.

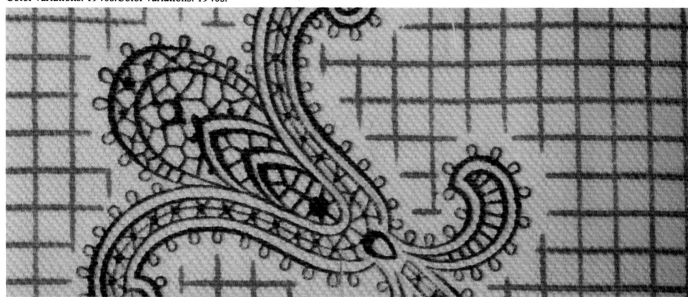

Color variations. 1940s.Color variations. 1940s.

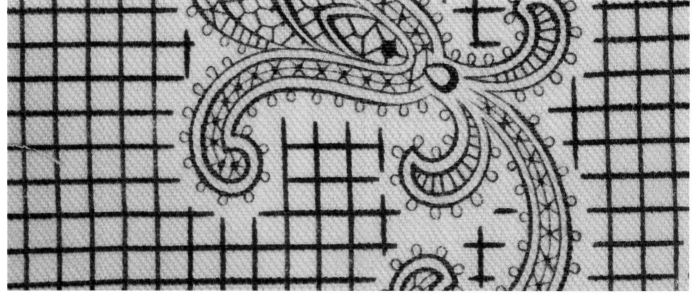

Psychedelic '60s

Paisley became a symbol of the counter-culture movement of the 1960s and '70s, evoking ethnic images and spiritual connotations of faraway India. Combined with flower power, the age-old design was reincarnated in hot new shades.

1960s.

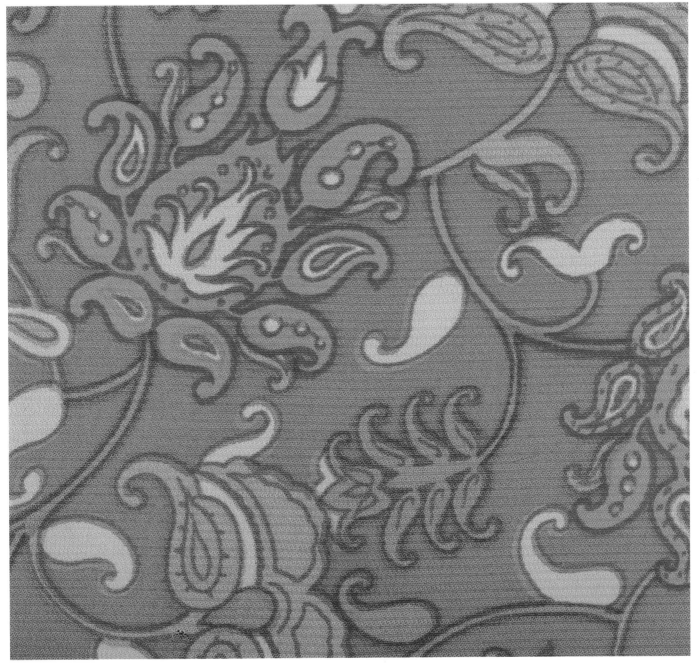

Italy, 1964.

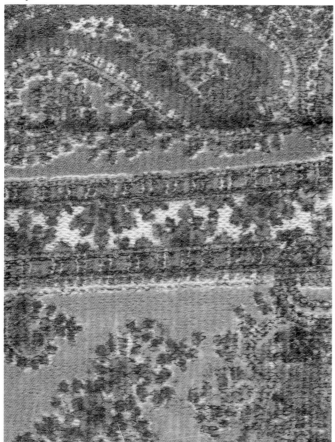

Italy, 1964.

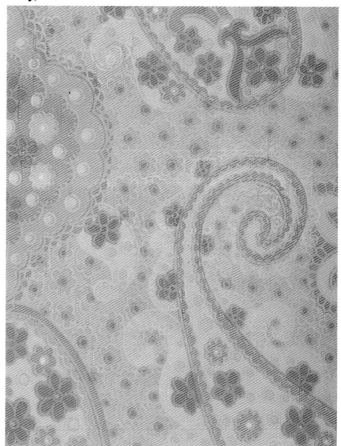

United States, 1964.

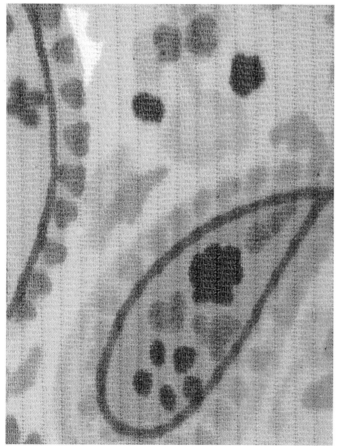

Italy, 1964.

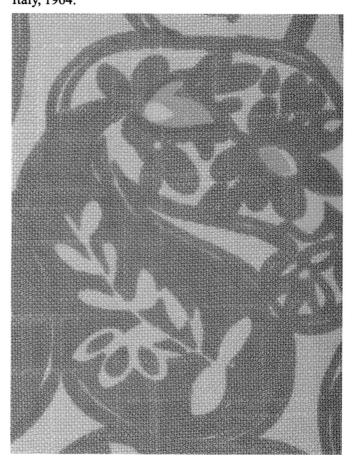

Italy, 1964.

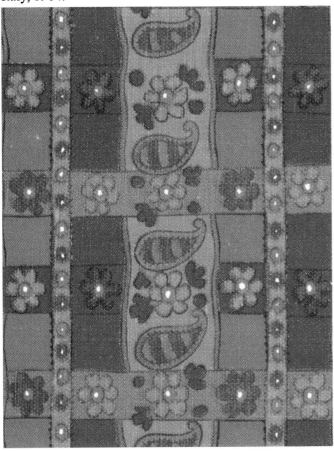

Italy, 1962.

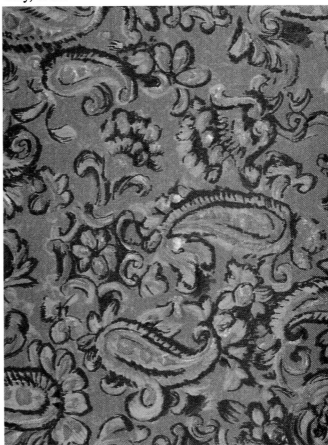

Italy, 1964.

Italy, 1962.

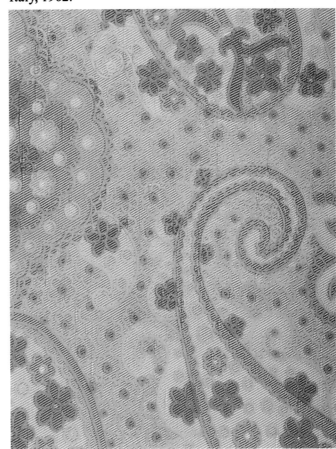

Italy, 1964.

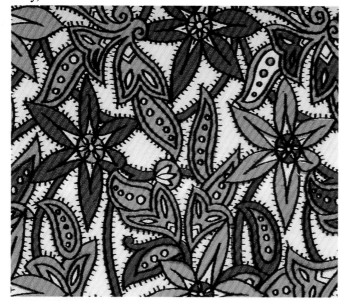

France, 1963.

United States, 1964.

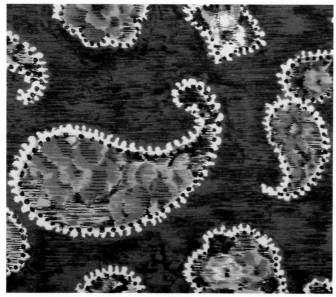

Italy, 1963.

France, 1963.

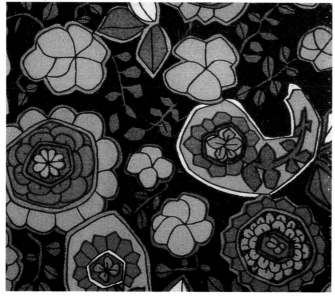

Italy, 1964.

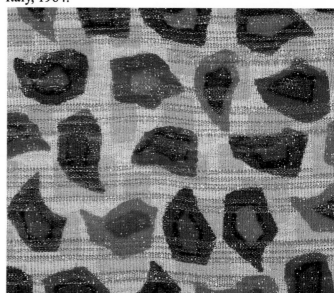

56

Italy, 1965.

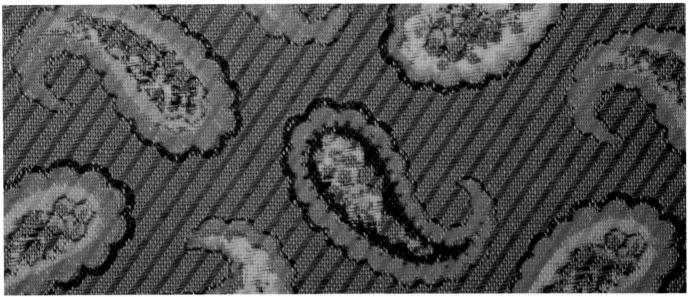

Italy, 1965.

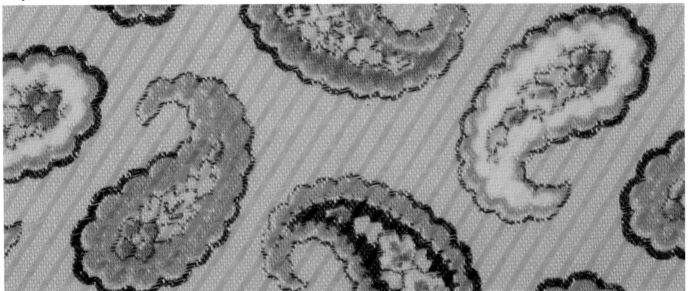

Italy, 1965.

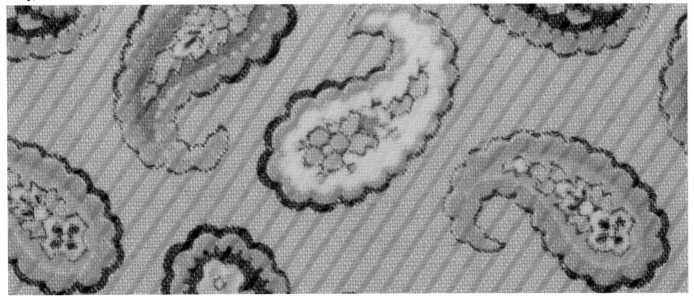

Silk. 1960s.

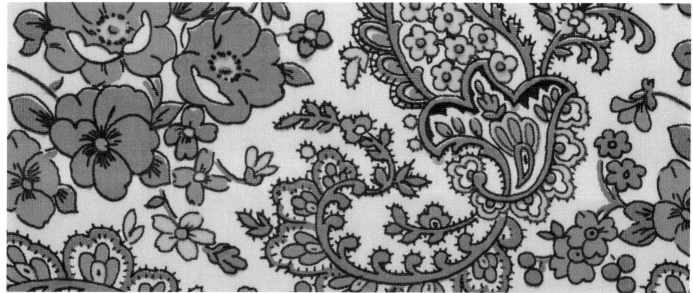

Silk. 1960s.

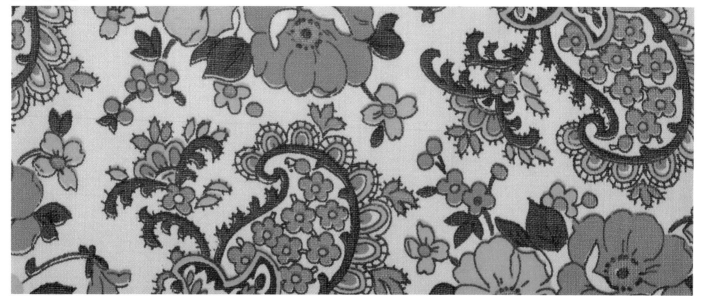

Silk. 1960s.

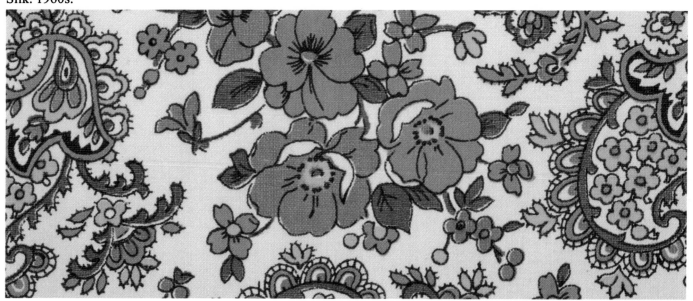

Favorite Colors

Certain colors have come to be associated with paisley. From the 1860s through the 1920s, muted red and pinks, known as "cinnamon pinks," or "double pinks," were staple colors for cotton prints and lent themselves well to a staple design—paisley. Turkey reds were the outstanding fabrics of the nineteenth century, with unrestrained colors that teamed up well with paisley. Purple, another color with an unruly reputation, has been paired extensively with paisley, as has indigo.

Pink and Red

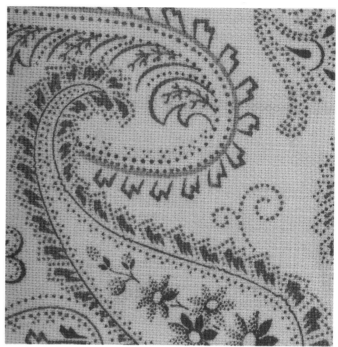

Cotton. 1940s.

Cotton. 1940s.

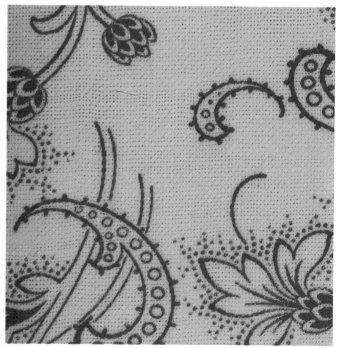

Cotton. 1940s.

Cotton. 1940s.

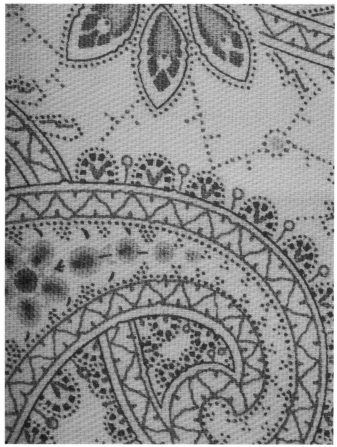

Cotton. 1940s.

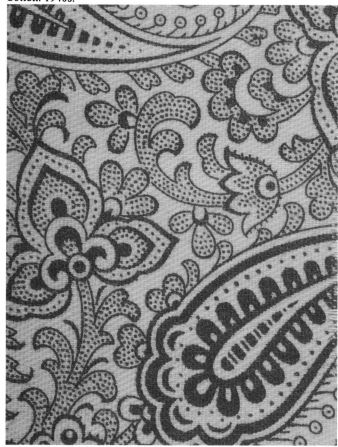

Cotton. 1940s.

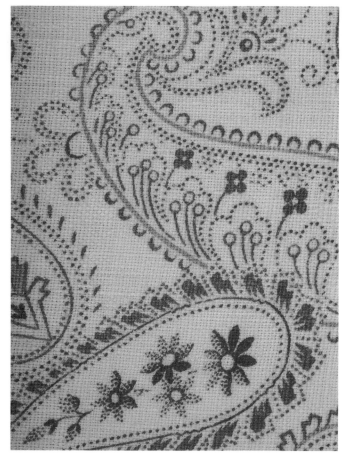

Cotton. 1950s.

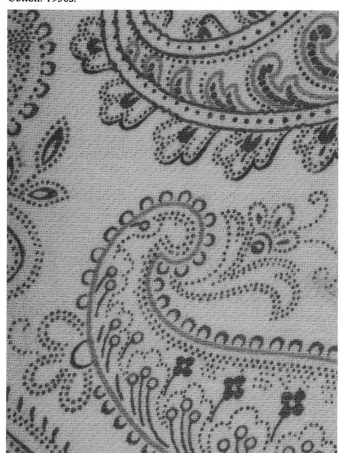

Cotton. 1950s.

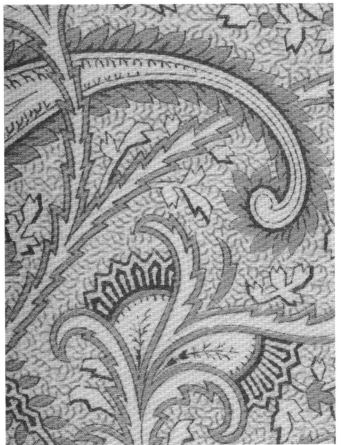

Cotton. 1950s.

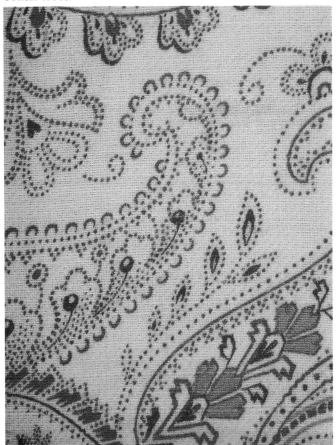

Cotton. 1950s.

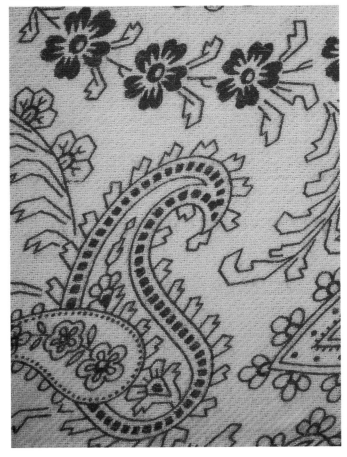

Cotton. 1950s.

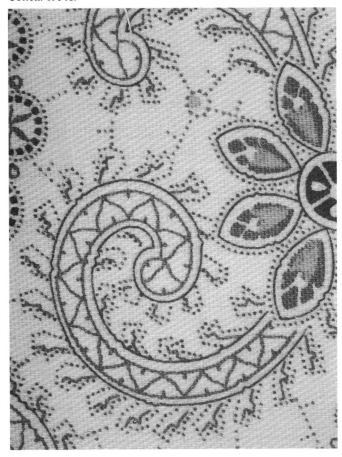

Cotton. 1950s.

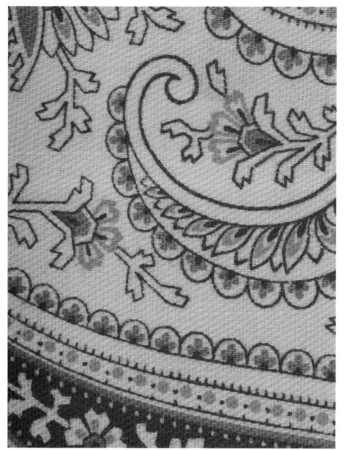

Cotton. 1950s.

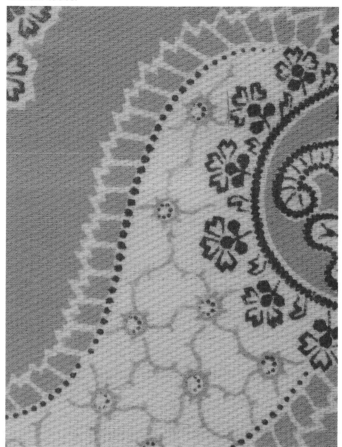

Cotton. 1950s.

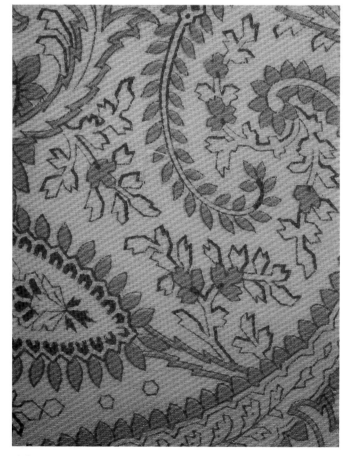

Cotton. 1950s.

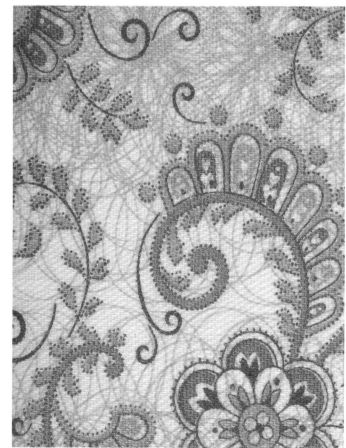

.Cotton. 1940s.

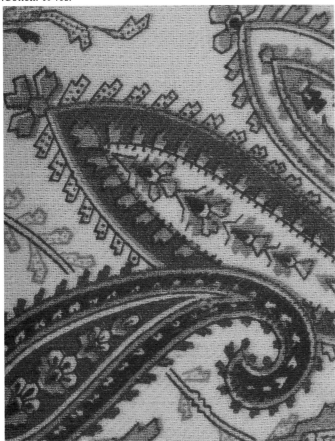

Cotton. 1950s.

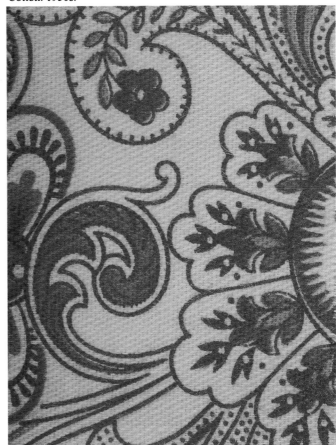

Cotton. 1950s.

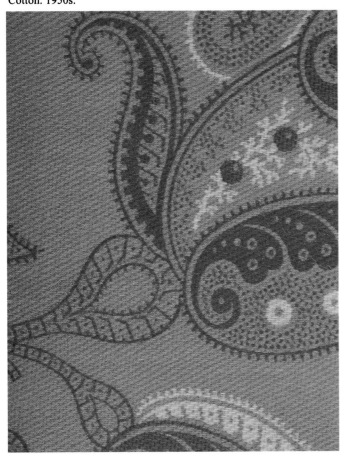

Cotton. 1940s.

Red, White, and Other

Cotton. 1950s.

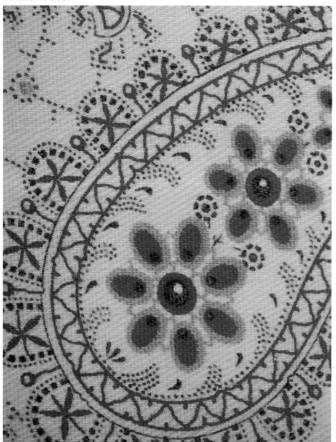

Cotton. 1940s.

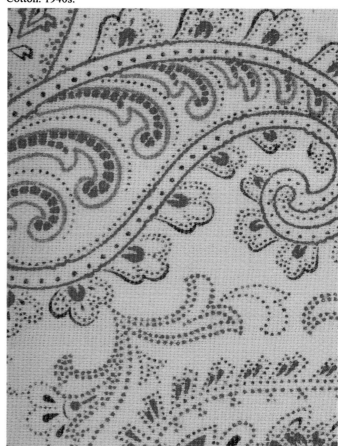

Cotton. 1950s.

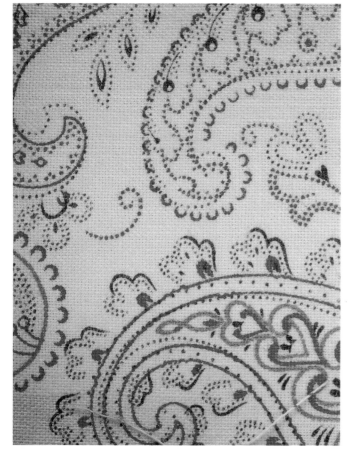

Cotton. 1950s.

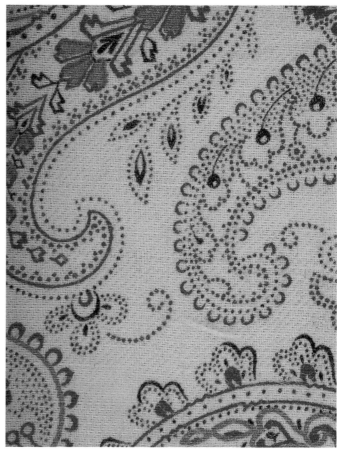

Cotton. 1950s.

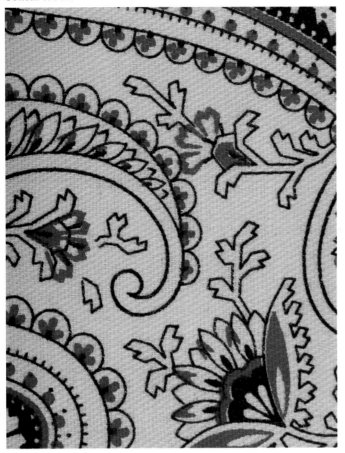

1960s.

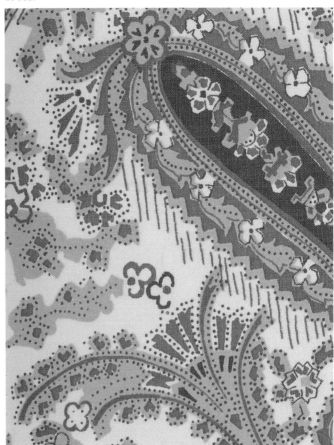

Cotton. 1940s.

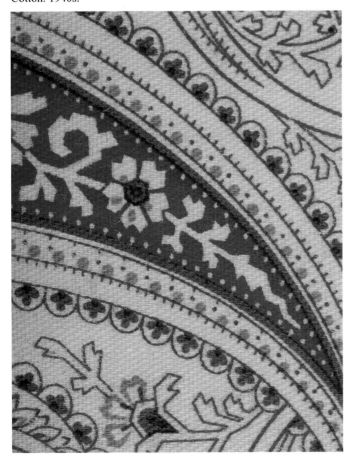

Cotton. 1940s

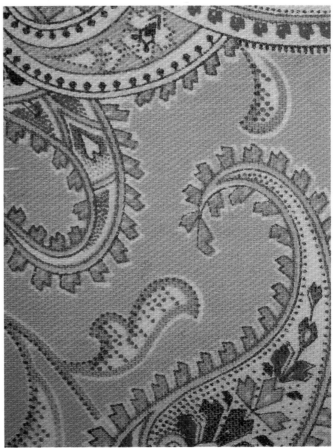

Turkey Red

Cotton. 1940s.

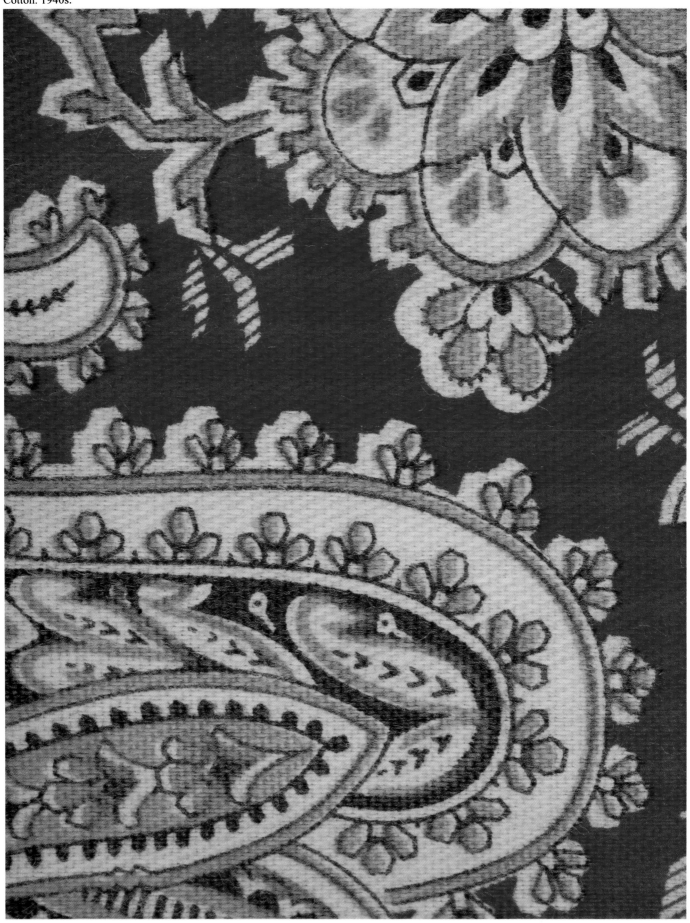

Cotton. 1950s.

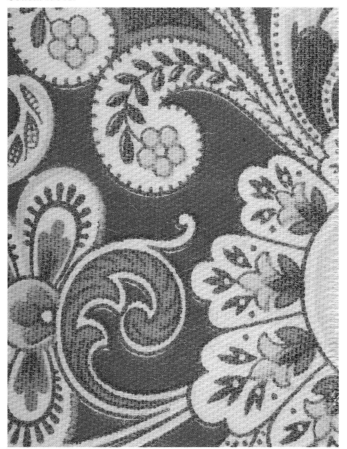

Cotton. 1940s.

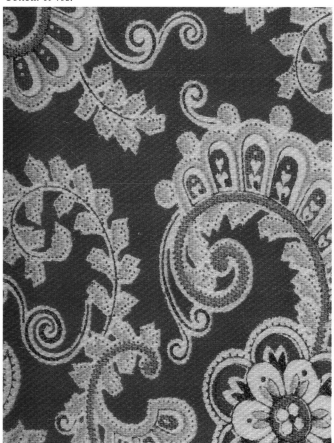

Cotton. 1940s.

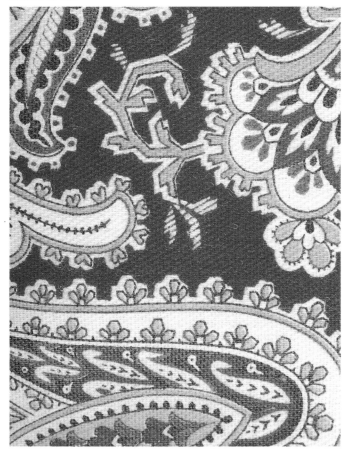

Cotton. 1940s.

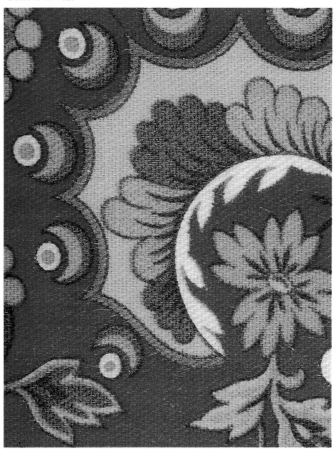

Cotton. 1940s.

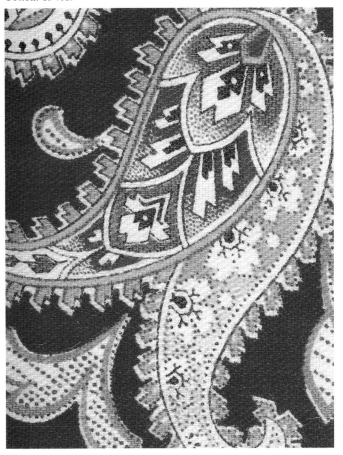

Cotton. 1950s.

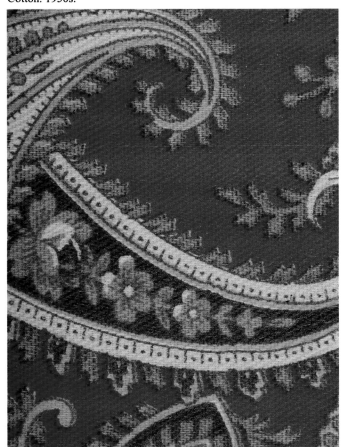

Cotton. 1950s.

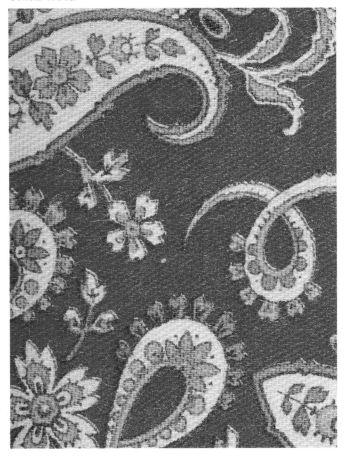

Cotton. 1940s.

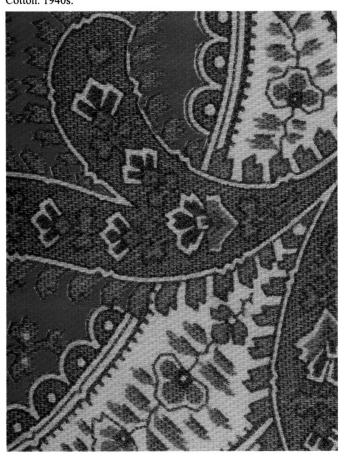

Cotton. 1940s.

Cotton. 1950s.

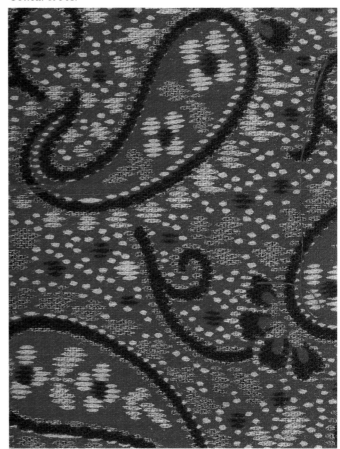

Cotton. 1940s.

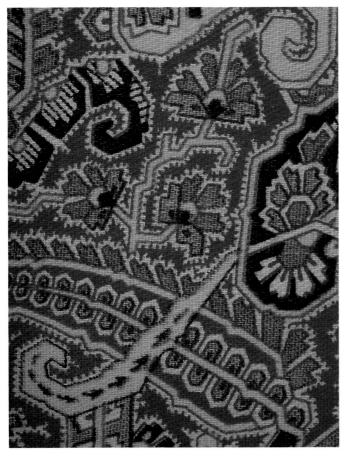

Cotton. 1940s.

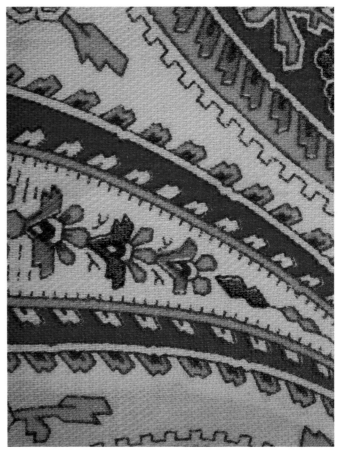

The Color Purple

Cotton. 1940s.

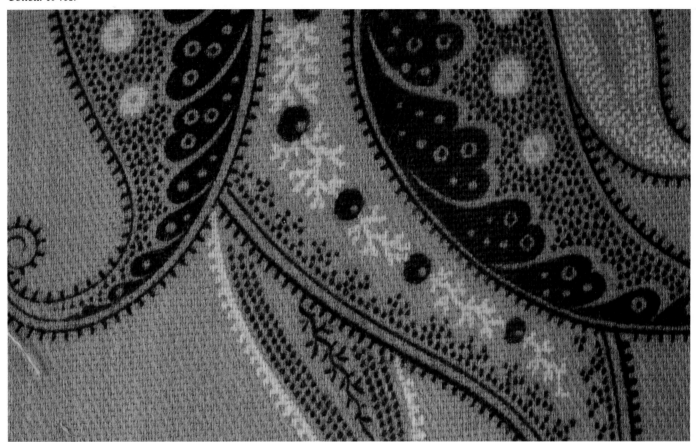

Cotton. 1940s.

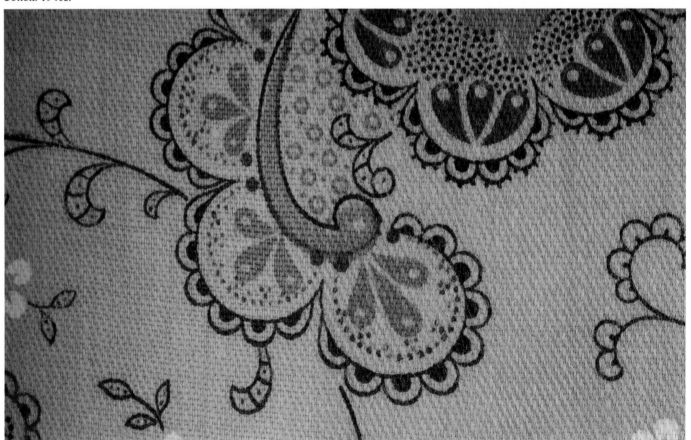

Cotton. 1950s.

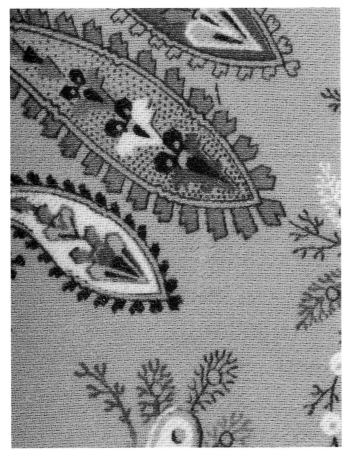

Cotton. 1940s.

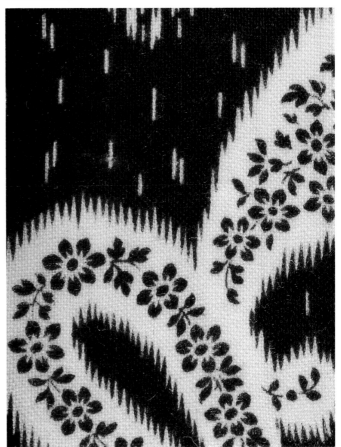

Cotton. 1940s.

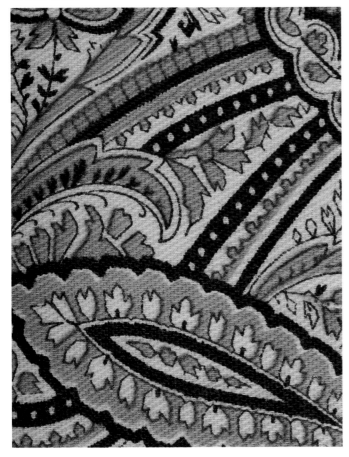

Cotton. 1950s.

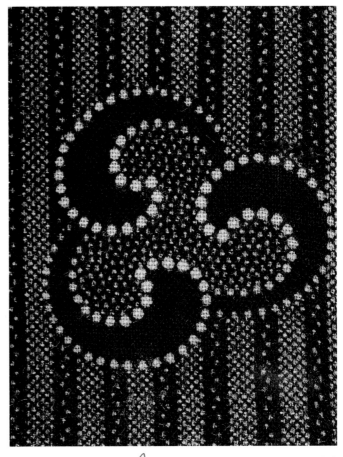

Indigo

Cotton. 1950s.

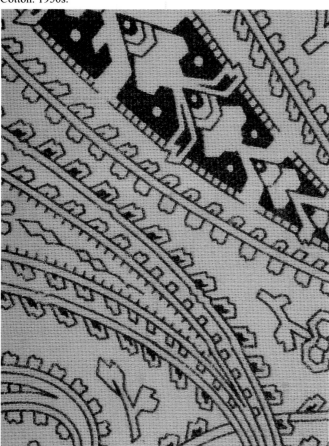

Cotton. 1950s.

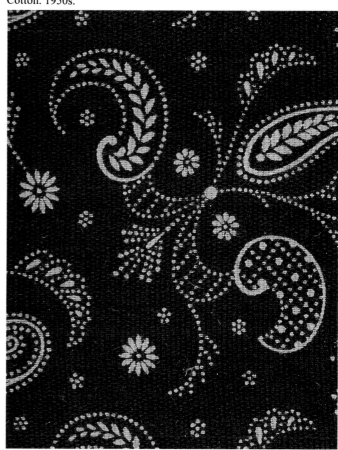

Cotton. 1950s.

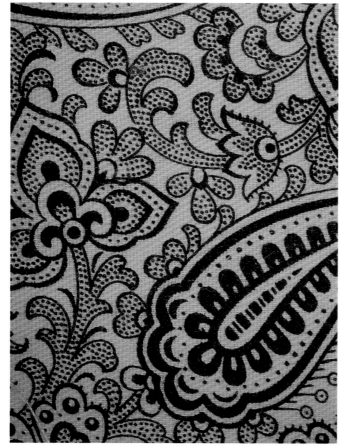

Cotton. 1950s.

Sand Ground

Cotton. 1940s.

France, 1964.

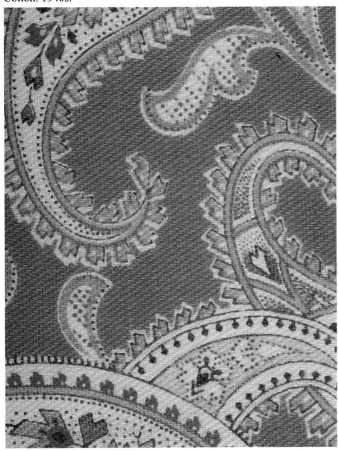

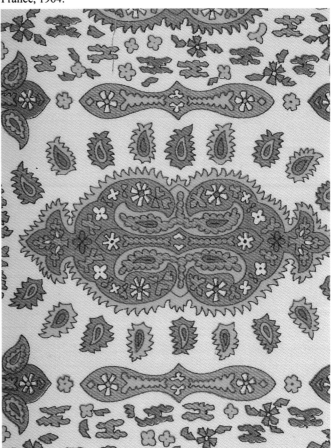

Cotton. 1950s.

Italy, 1964.

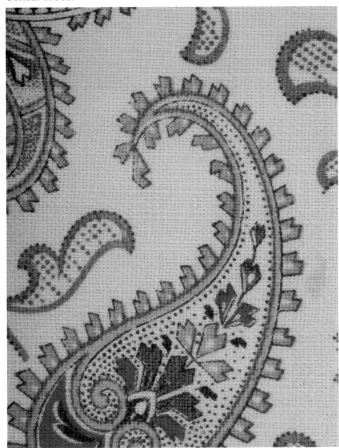

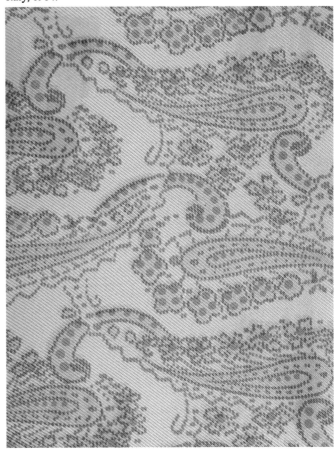

Dark Blue Ground

Cotton. 1950s.

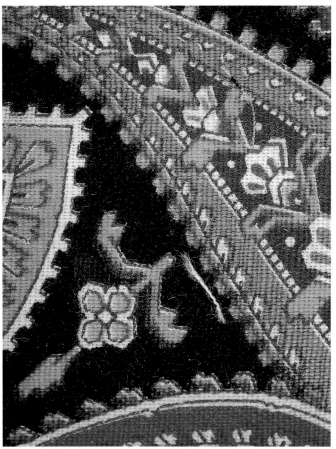

Cotton. 1940s.

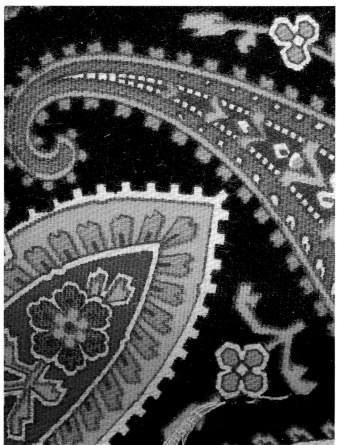

Cotton. 1940s.

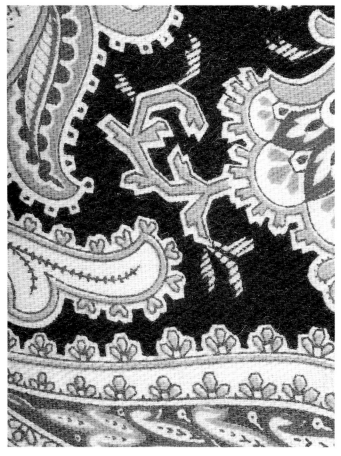

Cotton. 1950s.

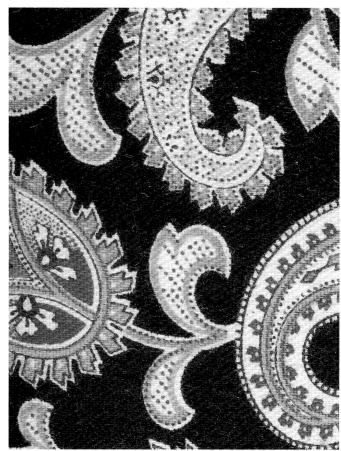

Chapter 8

Color Variations

Wild in form and spirit, paisley invites the designer to strike bold statements in color, to punctuate with neon hues, create contrasting borders, and fill vibrant shapes with every imaginable hue. The following pages explore some unique takes on the paisley shape, and the effect of different color variations on that design.

Silk.

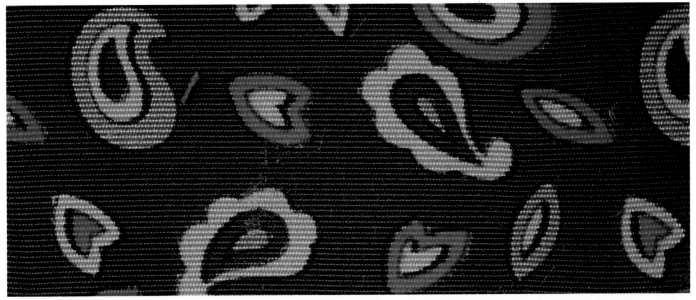

Silk.

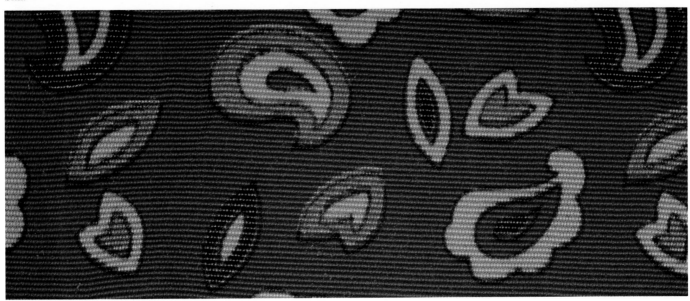

Silk.

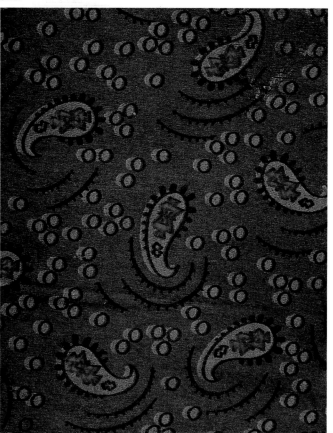

Silk.

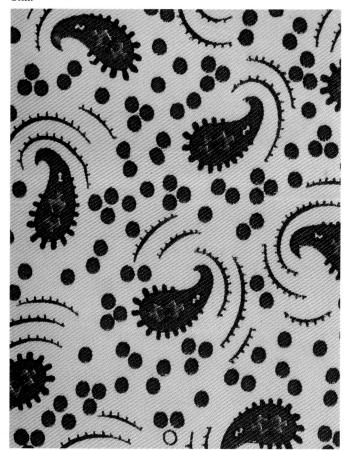

Silk.

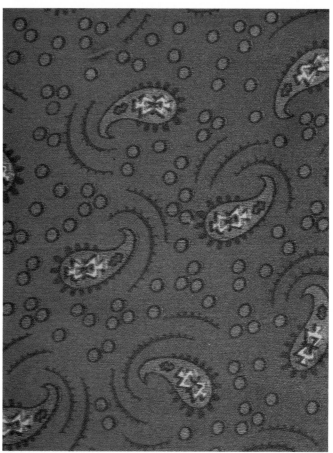

Silk.

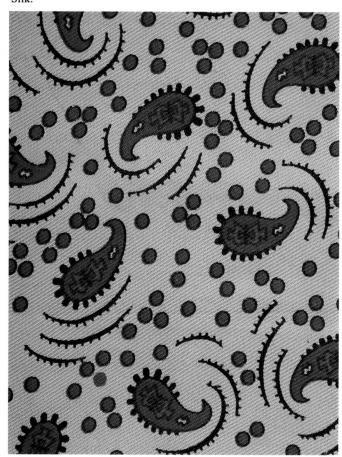

7 6

Cotton. United States, 1941.

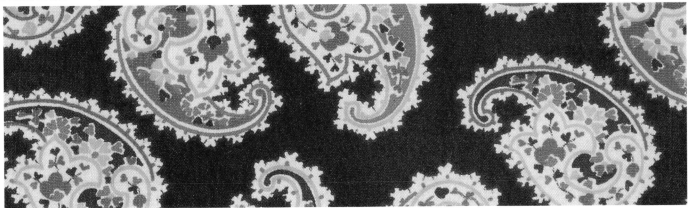

Cotton. United States, 1941.

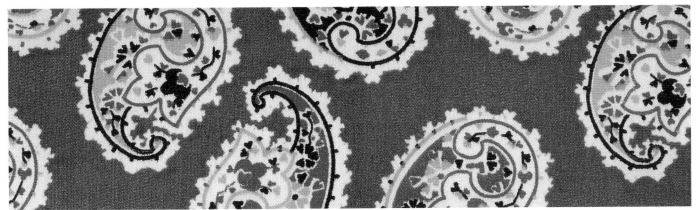

Cotton. United States, 1941.

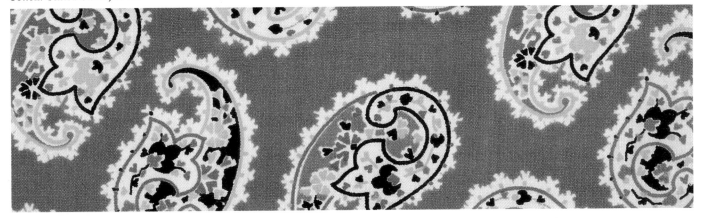

Cotton. United States, 1941.

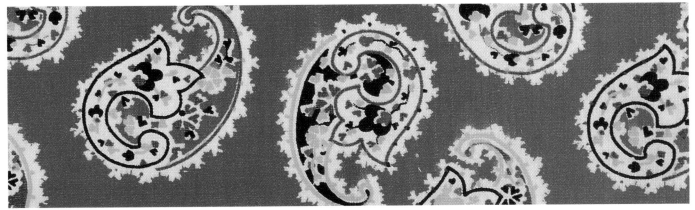

Silk.

Silk.

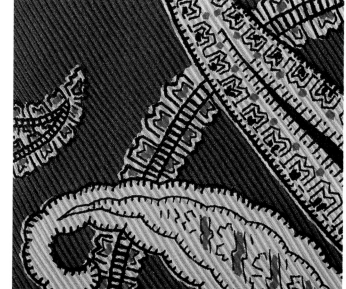

Silk.

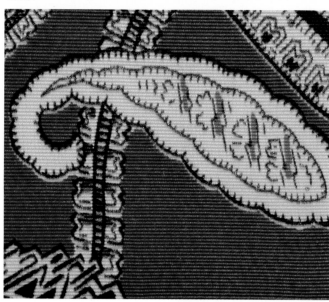

Silk.

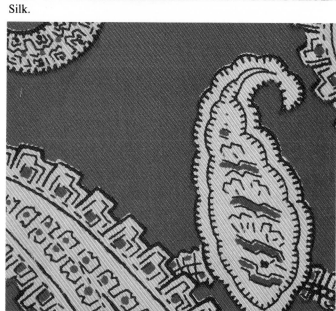

Silk.

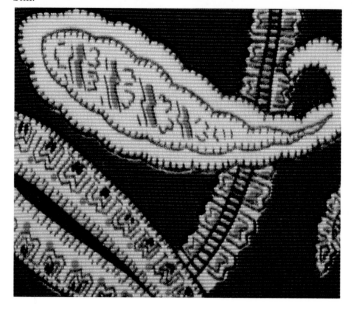

Silk.

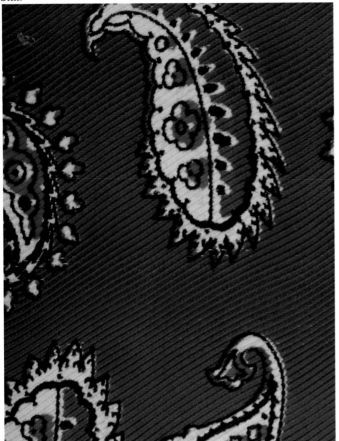

Silk.

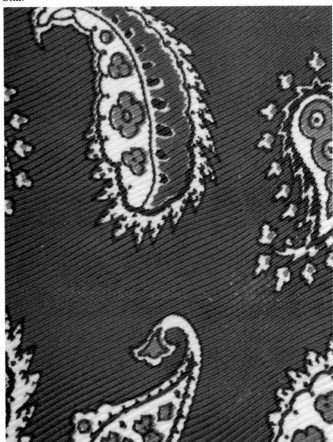

Silk blend, 1930s.

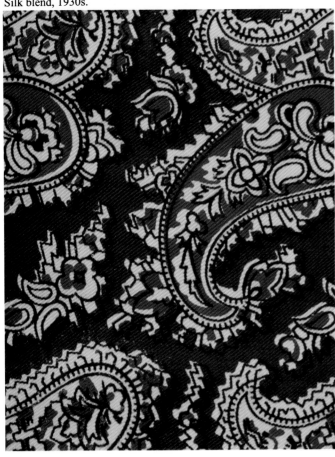

Silk blend, 1930s.

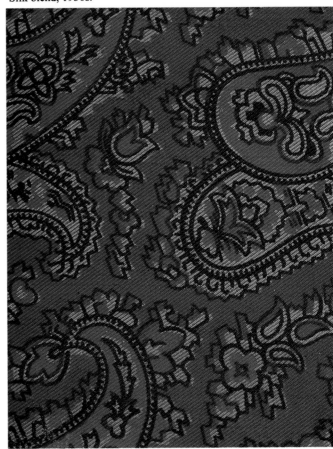

7 9

Silk blend, 1930s.

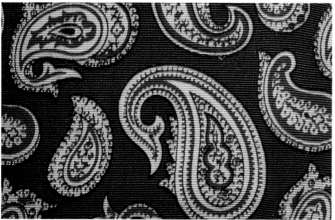

Silk blend, 1930s.

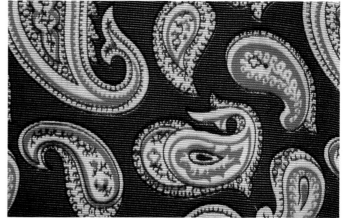

Silk blend, 1930s.

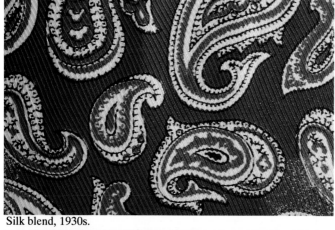

Silk blend, 1930s.

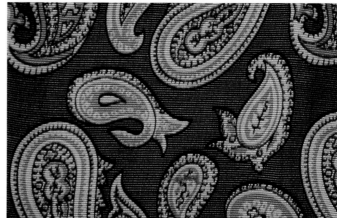

Silk blend, 1930s.

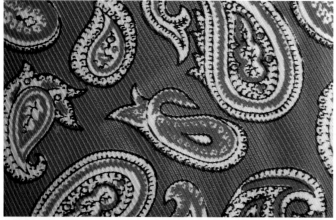

Silk blend, 1930s.

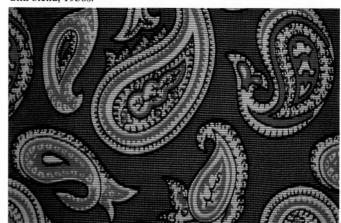

Silk blend, 1930s.

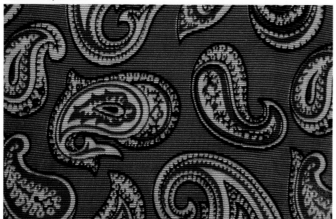

Silk blend, 1930s.

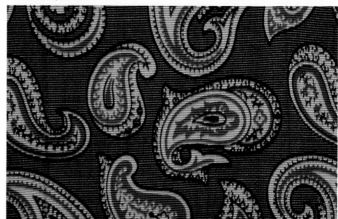

United States, 1930s.

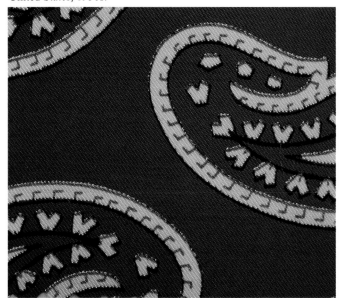

United States, 1930s.

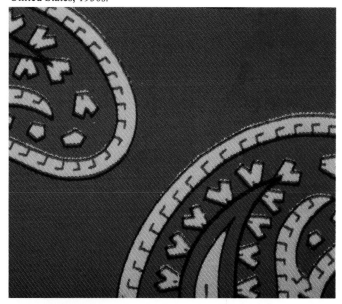

United States, 1930s.

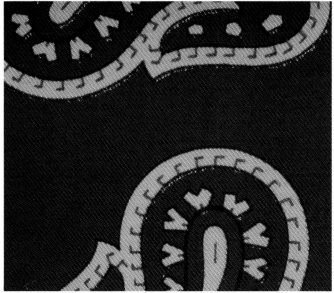

United States, 1930s.

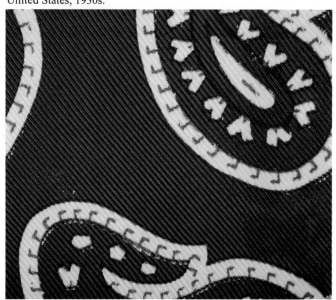

United States, 1930s.

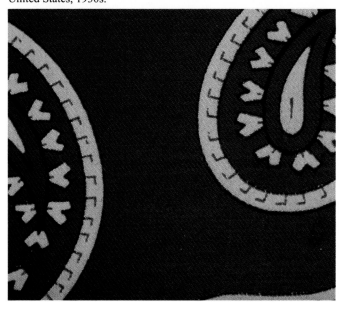

United States, 1930s.

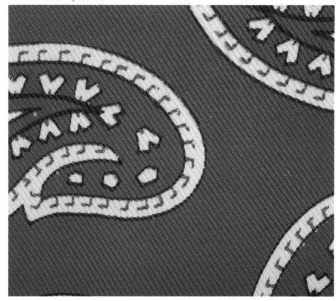

Silk.

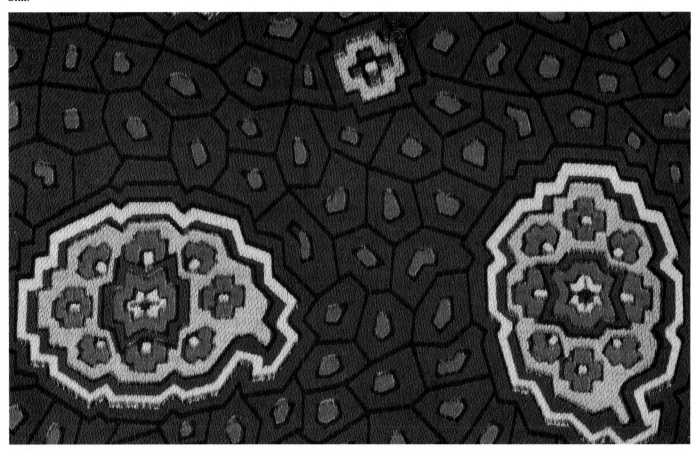

Silk.

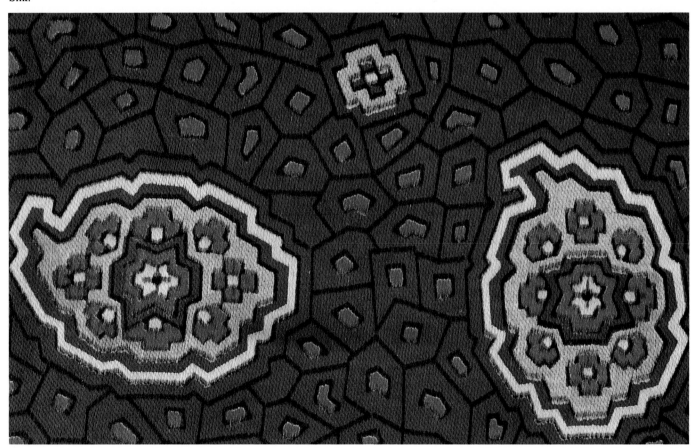

Silk. 1960s.

Silk. 1960s.

Silk. 1960s.

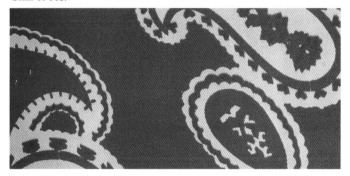

Silk. 1960s.

Silk. 1960s.

Silk. 1960s.

Silk. 1960s.

Silk. 1960s.

Silk. 1960s.

Silk. 1960s.

Silk. Late 1950s.

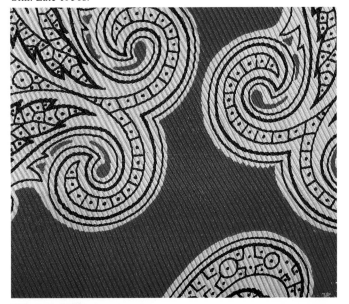

Silk. Late 1950s.

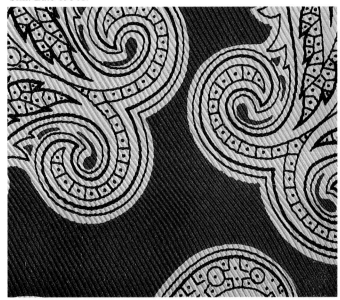

Silk. Late 1950s.

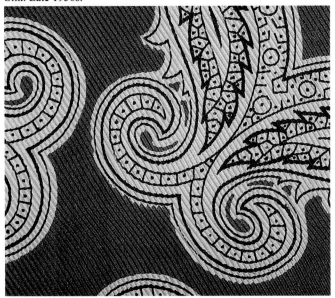

Silk. Late 1950s.

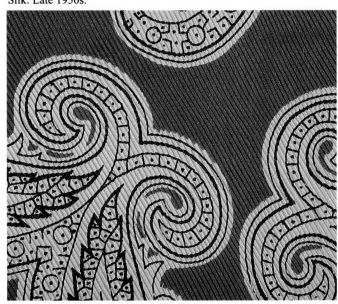

Silk. Late 1950s.

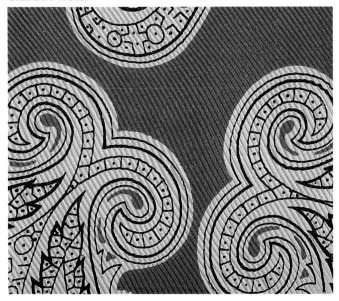

Silk. Late 1950s.

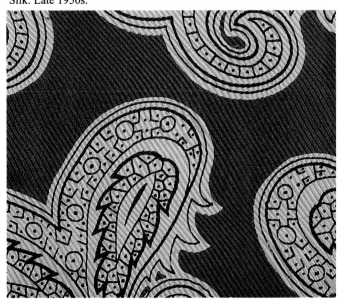

United States, 1930s.

United States, 1930s.

United States, 1930s.

United States, 1930s.

United States, 1930s.

United States, 1930s.

Silk. Late 1950s.

Silk. Late 1950s.

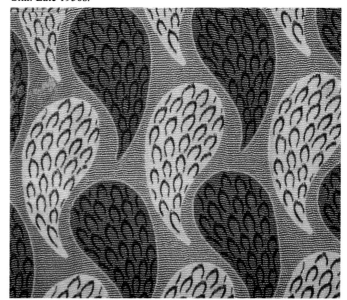

Silk. Late 1950s.

Silk. Late 1950s.

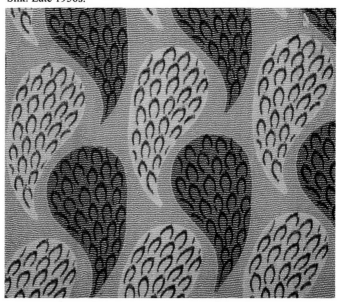

Silk. Late 1950s.

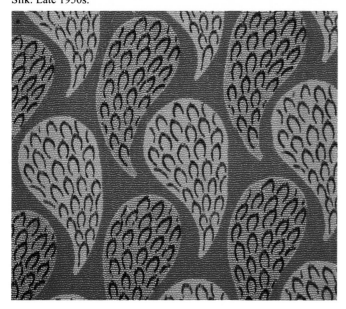

Silk. Late 1950s.

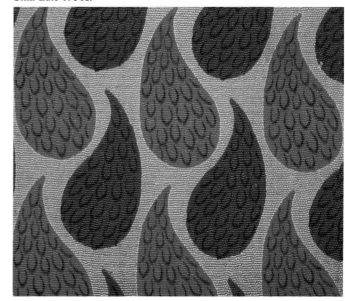

Silk. Late 1950s.

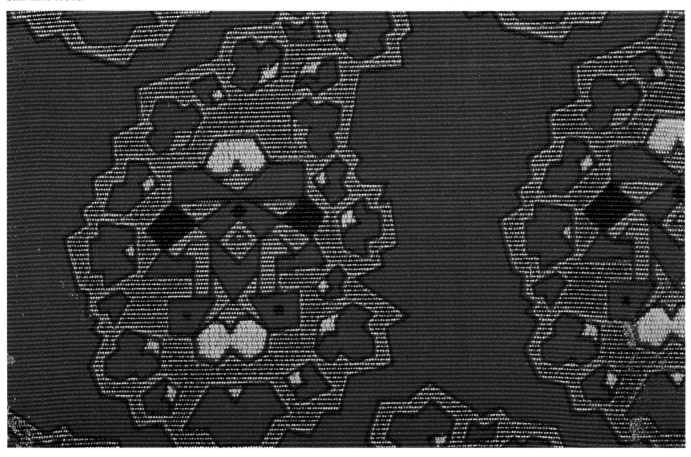

Silk. Late 1950s.

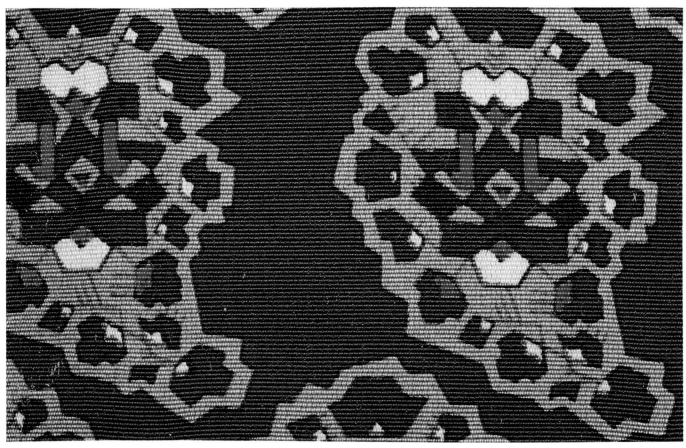

Silk.

Silk.

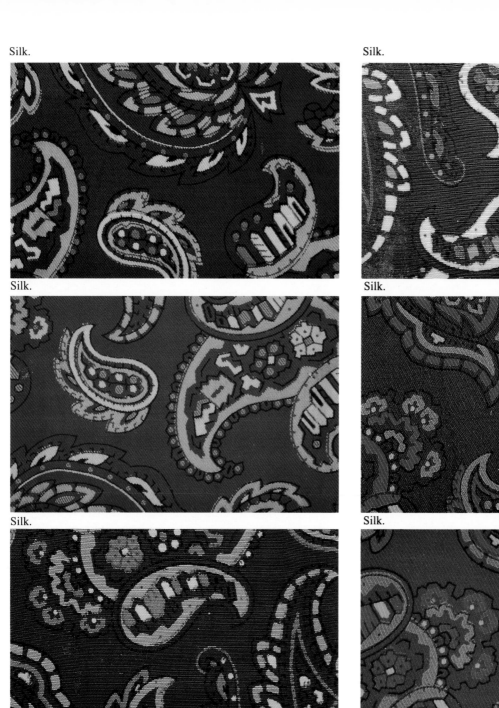

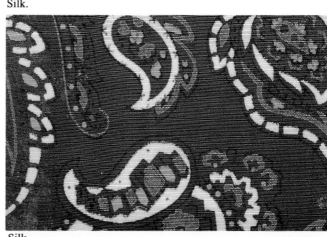

Silk.

Silk.

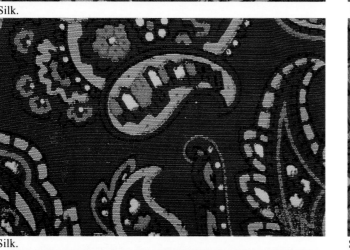

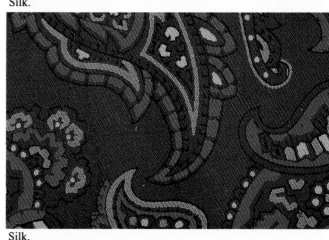

Silk.

Silk.

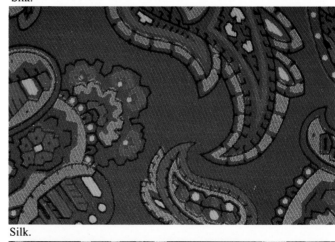

Silk.

Silk.

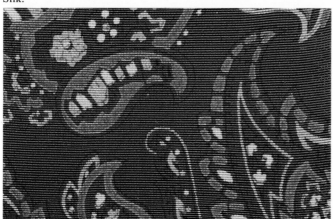

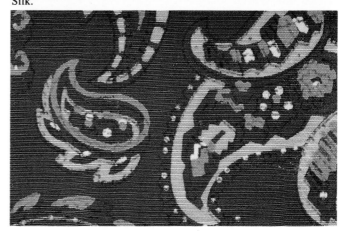

Silk.

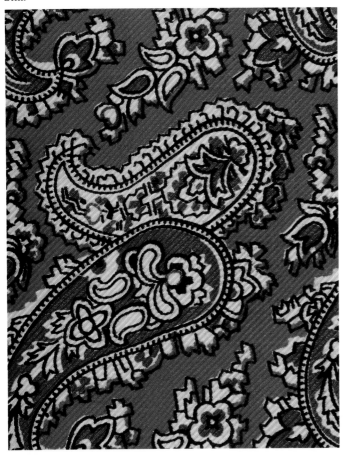

Silk.

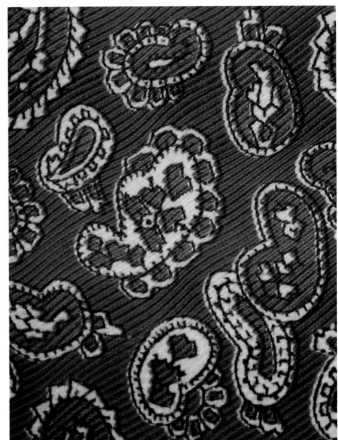

Silk.

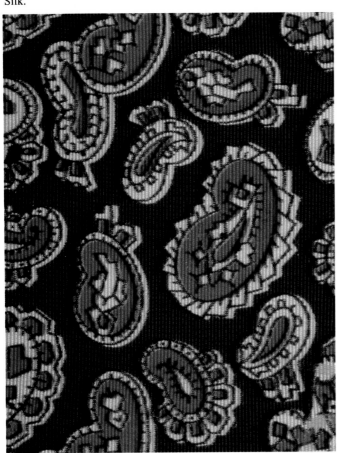

Silk.

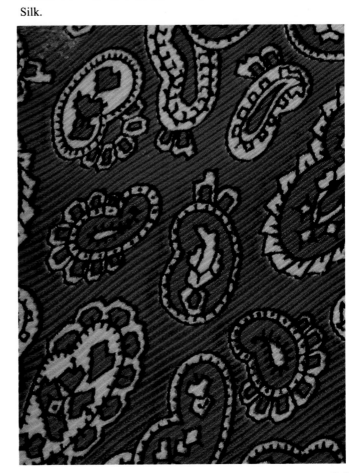

Silk.

Silk.

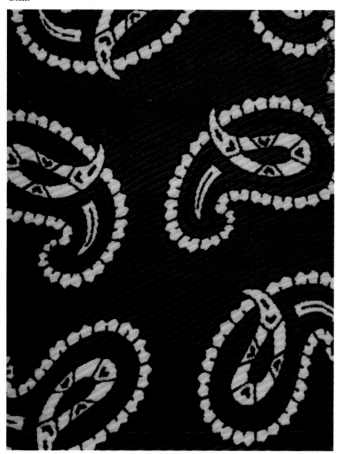 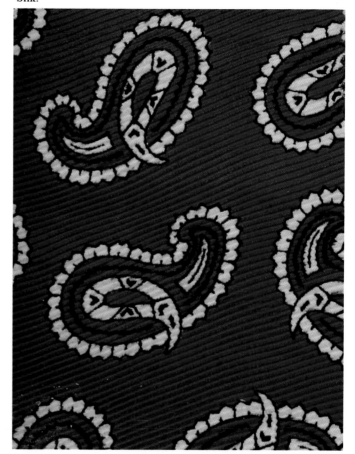

Silk.

Silk.

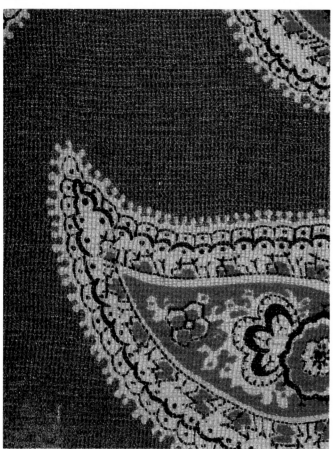 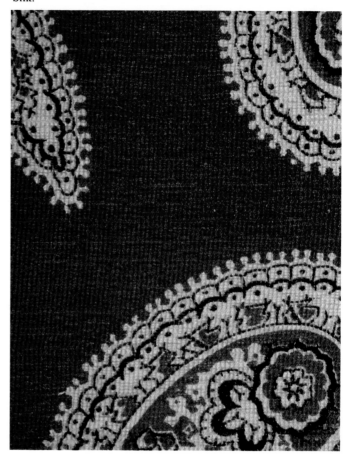

Silk. 1960s.

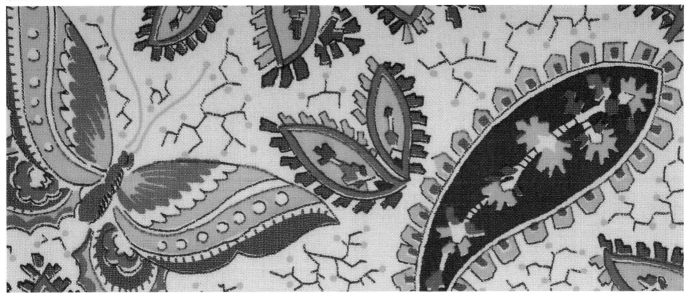

Silk. 1960s.

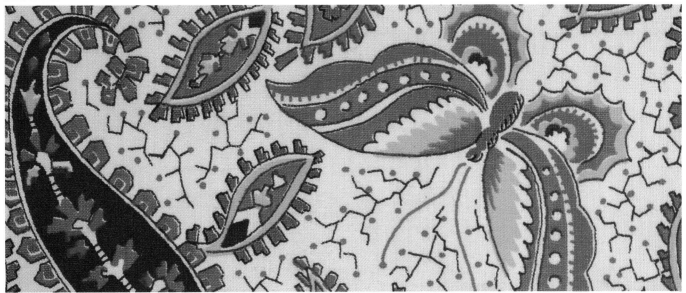

Silk. 1960s.

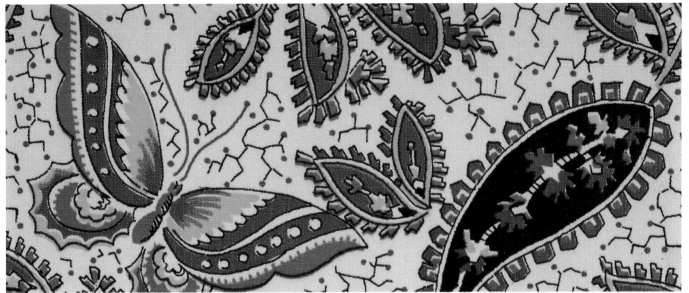

Italy, 1964.

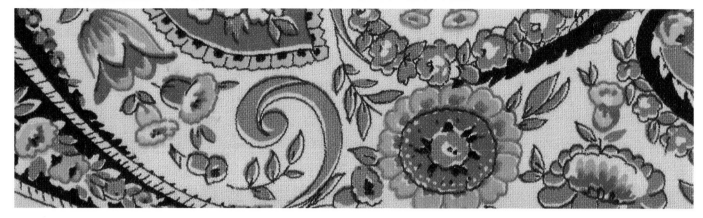

Italy, 1964.

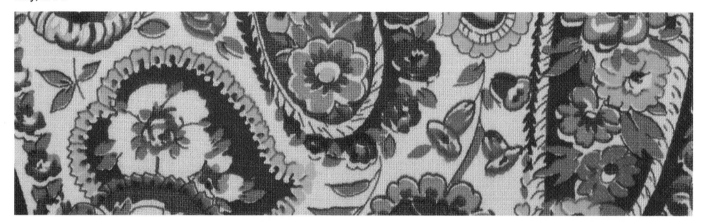

Italy, 1964.

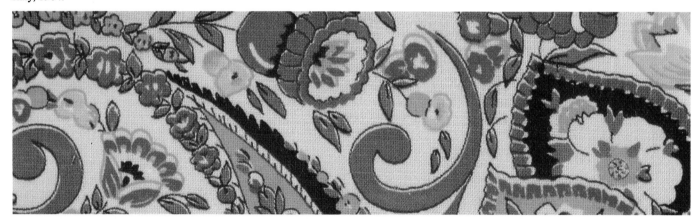

Italy, 1964.

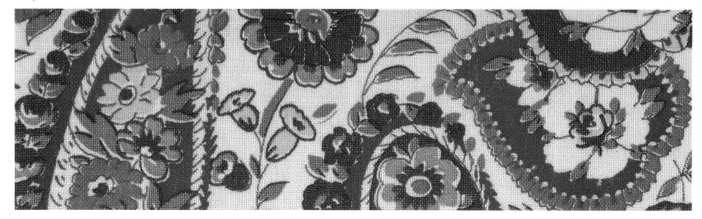

Cotton. United States, 1941.

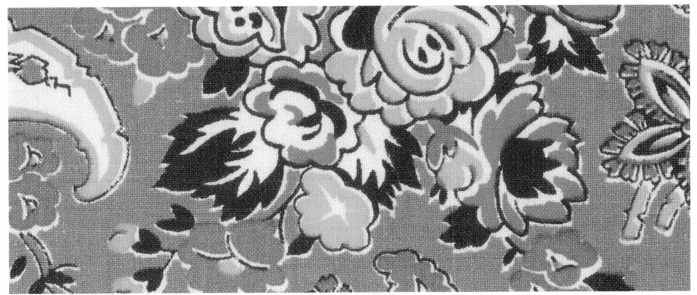

Cotton. United States, 1941.

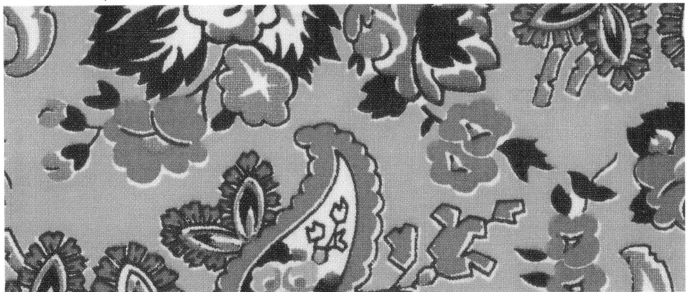

Cotton. United States, 1941.

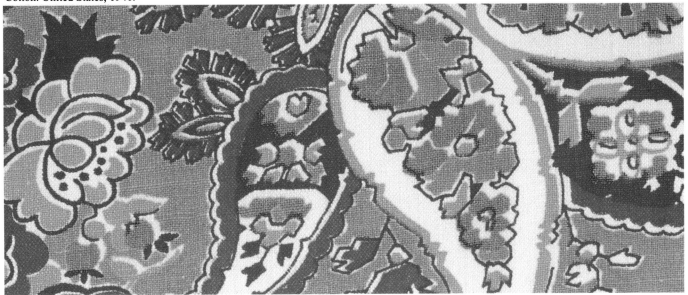

One Pattern/30 Variations

Silk. 1960s.

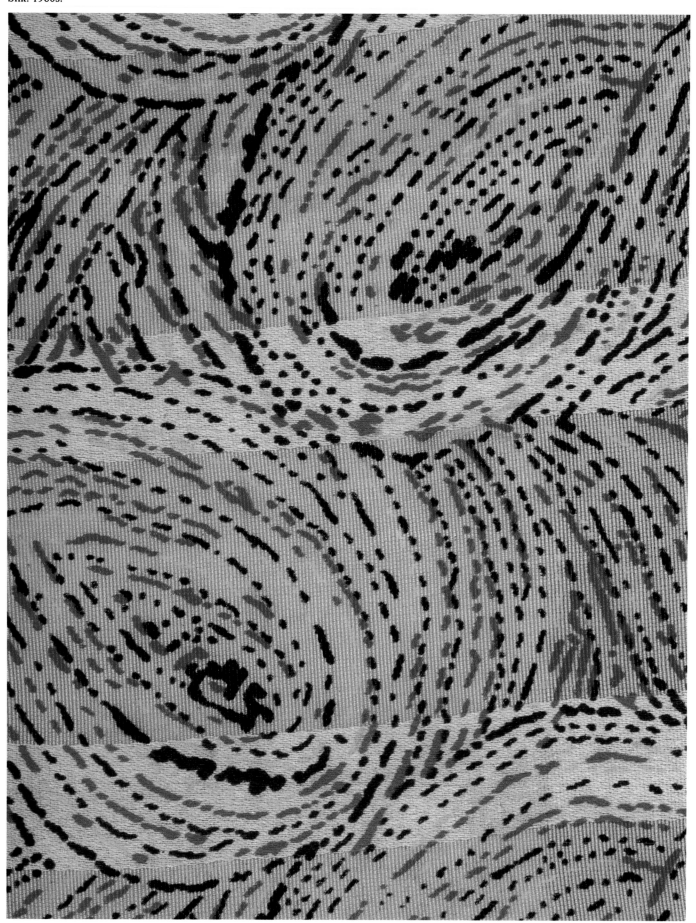

Silk. 1960s.

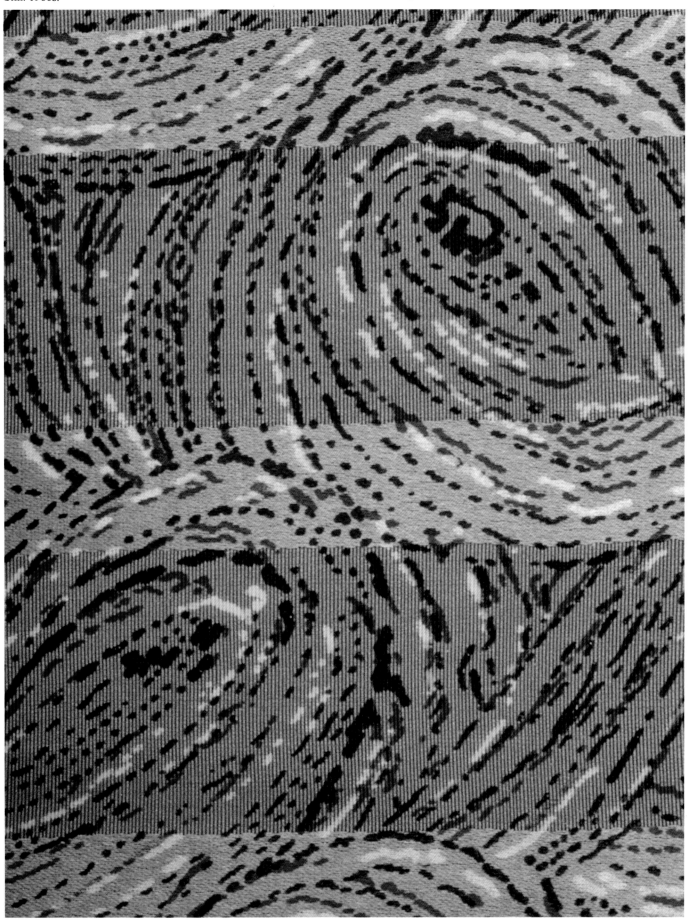

Silk. 1960s.

Silk. 1960s.

Silk. 1960s.

Silk. 1960s.

Silk. 1960s.

Silk. 1960s.

Silk. 1960s.

Silk. 1960s.

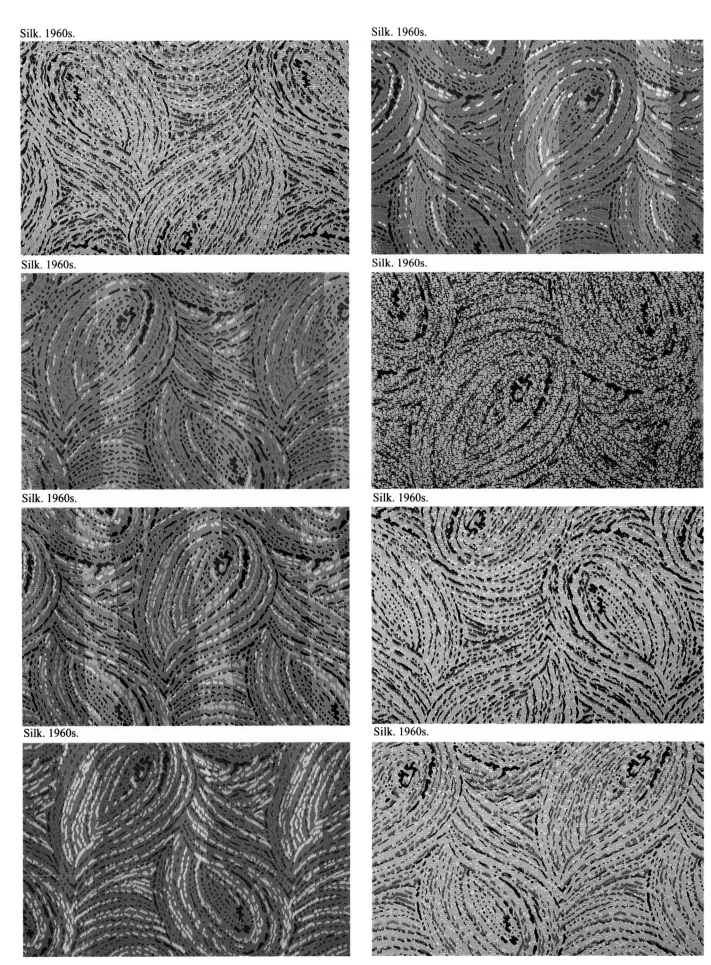

Silk. 1960s.

Silk. 1960s.

Silk. 1960s.

Silk. 1960s.

Silk. 1960s.

Silk. 1960s.

Silk. 1960s.

Silk. 1960s.

Silk. 1960s.

Silk. 1960s.

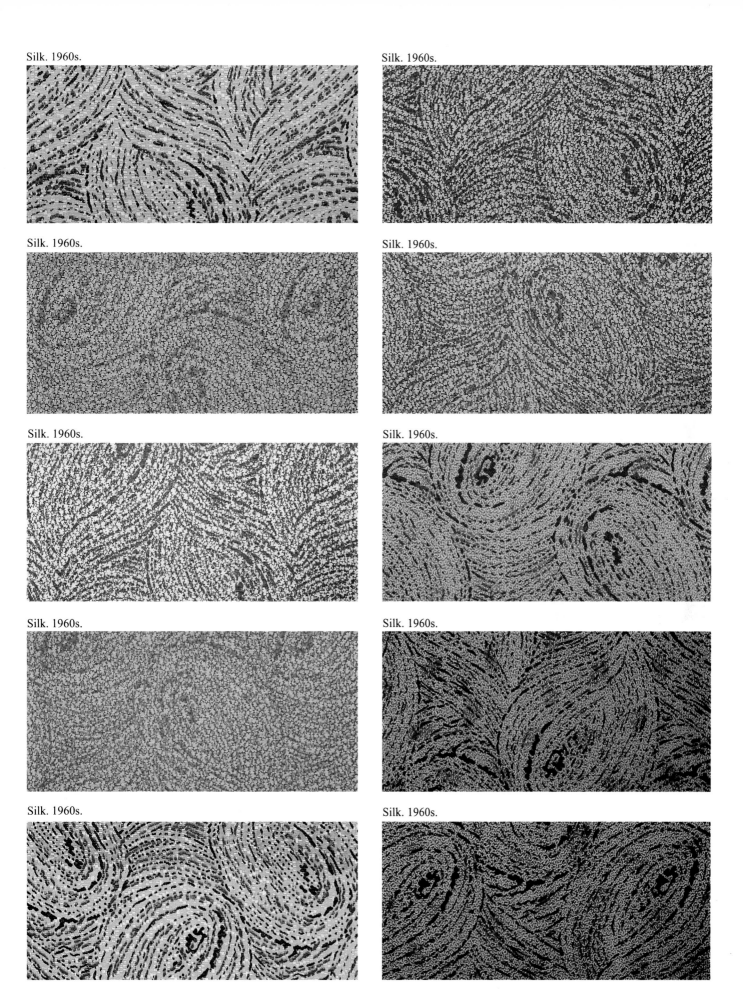

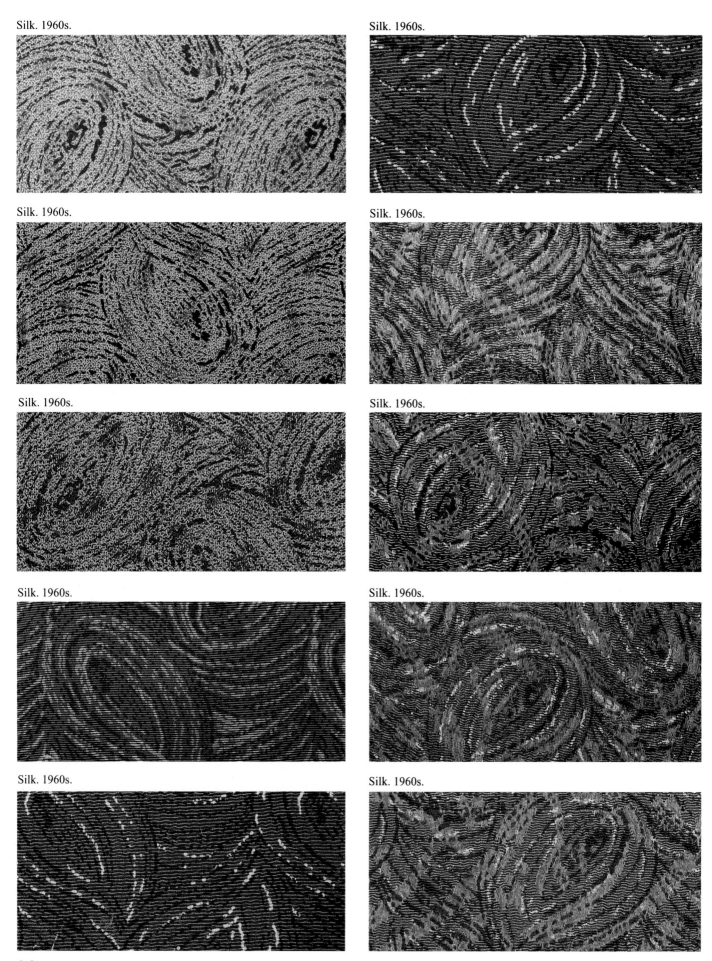

Silk. 1960s.

Silk. 1960s.

Silk. 1960s.

Silk. 1960s.

Silk. 1960s.

Silk. 1960s.

Silk. 1960s.

Silk. 1960s.

Silk. 1960s.

Silk. 1960s.

One Pattern/48 Variations

Silk. 1960s.

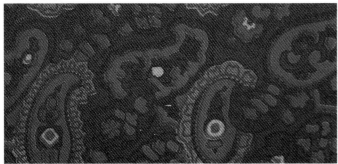

Silk. 1960s.

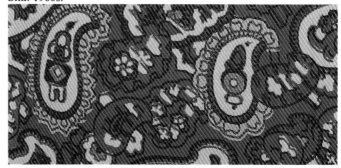

Silk. 1960s.

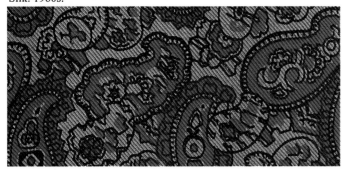

Silk. 1960s.

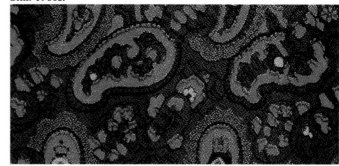

Silk. 1960s.

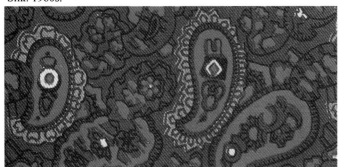

Silk. 1960s.

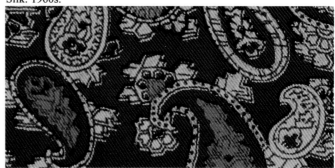

Silk. 1960s.

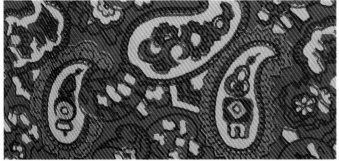

Silk. 1960s.

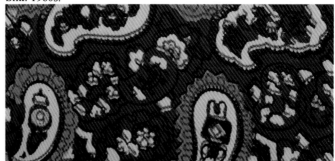

Silk. 1960s.

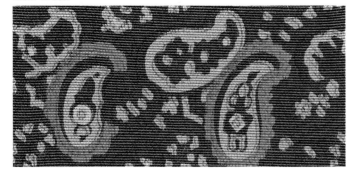

Silk. 1960s.

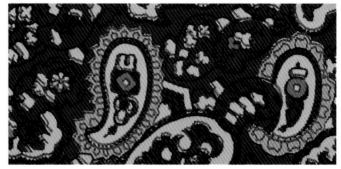

Silk. 1960s.

Silk. 1960s.

Silk. 1960s.

Silk. 1960s.

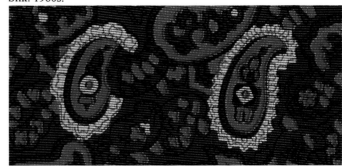

Silk. 1960s.

Silk. 1960s.

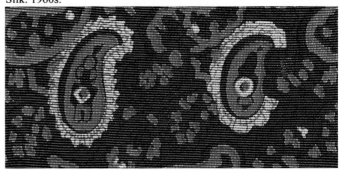

Silk. 1960s.

Silk. 1960s.

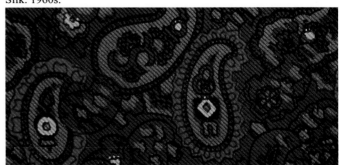

Silk. 1960s.

Silk. 1960s.

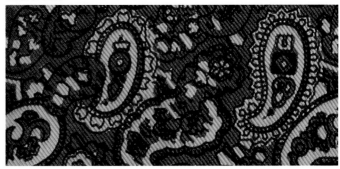

100

Silk. 1960s.

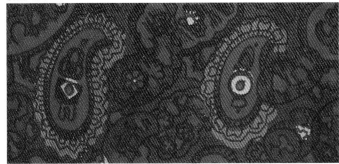

Silk. 1960s.

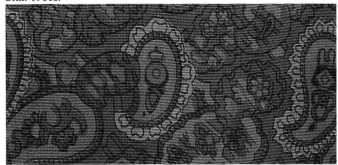

Silk. 1960s.

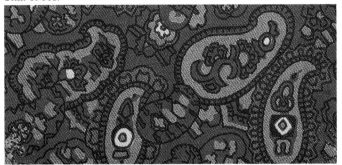

Silk. 1960s.

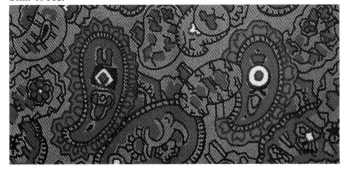

Silk. 1960s.

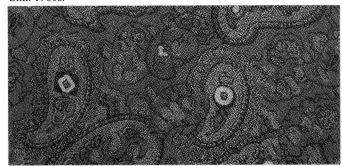

Silk. 1960s.

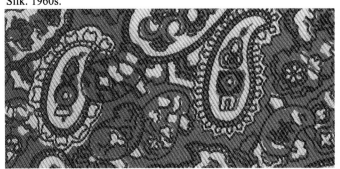

Silk. 1960s

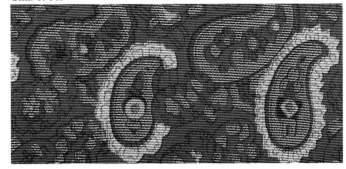

Silk. 1960s.

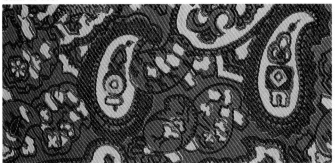

Silk. 1960s.

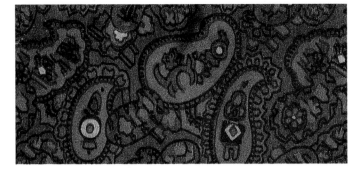

Silk. 1960s.

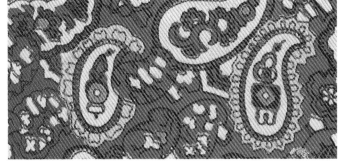

Silk. 1960s.

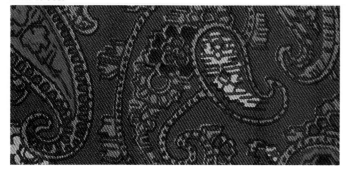

Silk. 1960s.

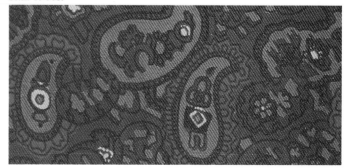

Silk. 1960s.

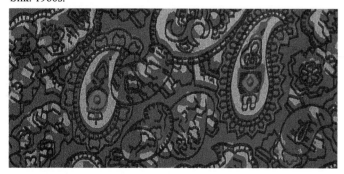

Silk. 1960s.

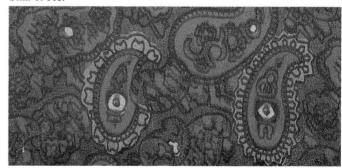

Silk. 1960s.

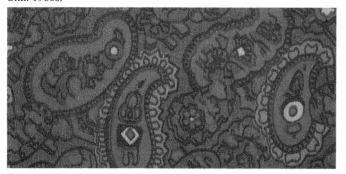

Silk. 1960s.

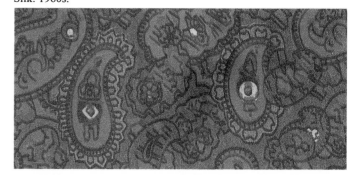

Silk. 1960s.

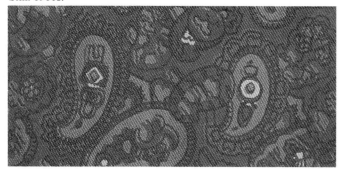

Silk. 1960s.

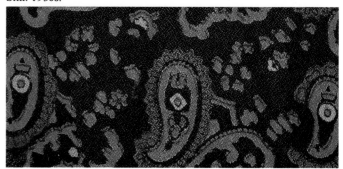

Silk. 1960s.

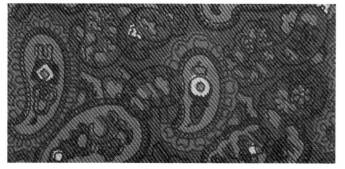

Silk. 1960s.

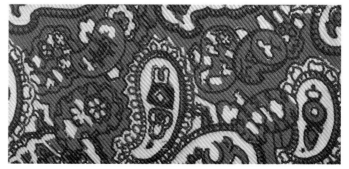

102

Silk. 1960s.

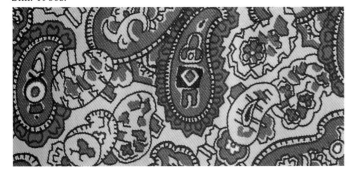

Silk. 1960s.

Silk. 1960s.

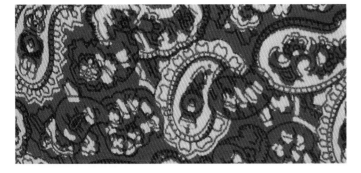

Silk. 1960s.

Silk. 1960s.

Silk. 1960s.

Silk. 1960.

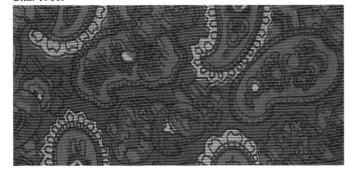

Silk. 1960s.

One Pattern/75 Variations

Silk. 1960s.

Silk. 1960s.

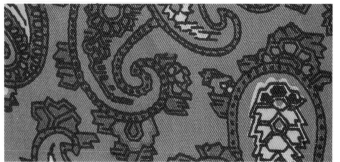

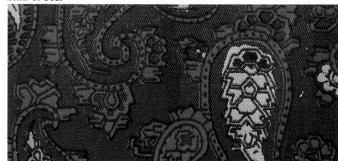

Silk. 1960s.

Silk. 1960s.

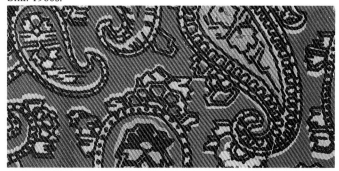

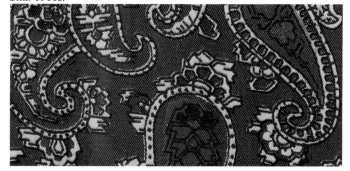

Silk. 1960s.

Silk. 1960s.

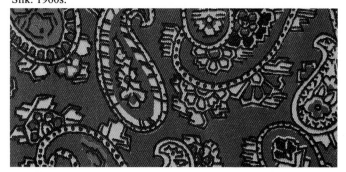

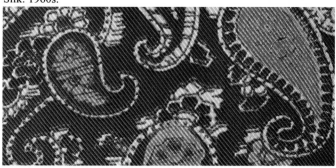

Silk. 1960s.

Silk. 1960s.

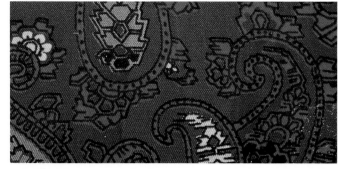

Silk. 1960s.

Silk. 1960s.

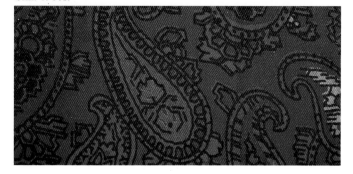

Silk. 1960s.

Silk. 1960s.

Silk. 1960s.

Silk. 1960s.

Silk. 1960s.

Silk. 1960s.

Silk. 1960s.

Silk. 1960s.

Silk. 1960s.

Silk. 1960s.

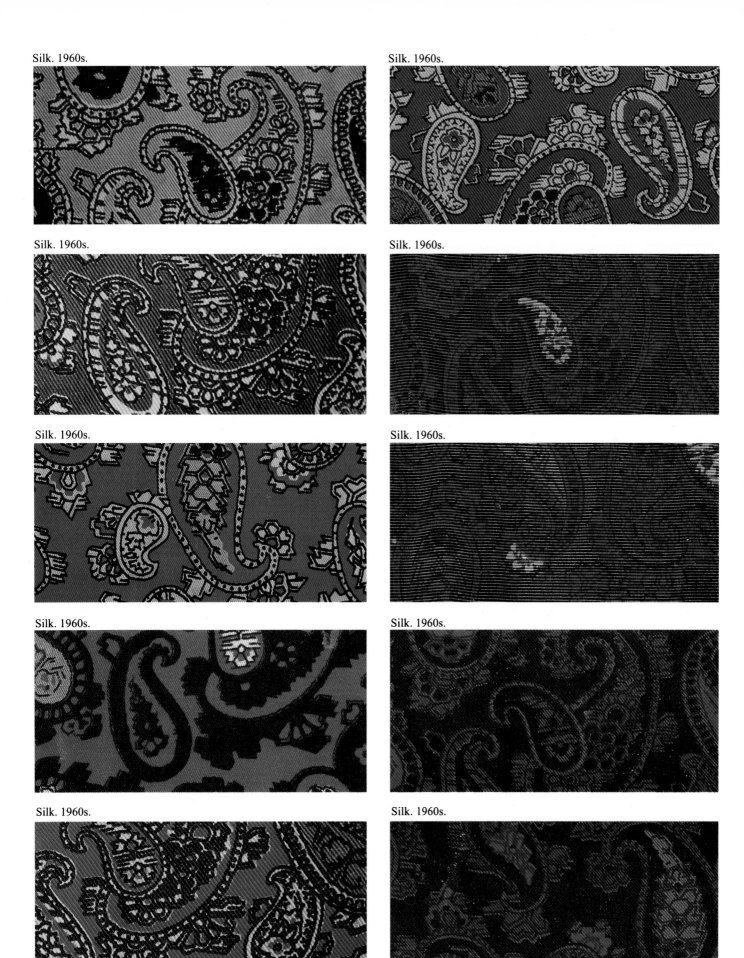

Silk. 1960s.

Silk. 1960s.

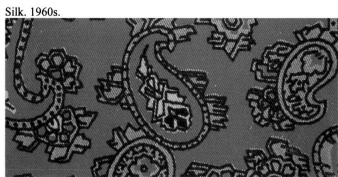

Silk. 1960s.

Silk. 1960s.

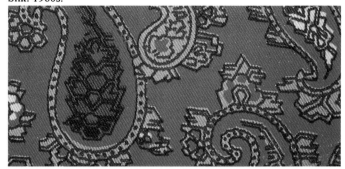

Silk. 1960s.

Silk. 1960s.

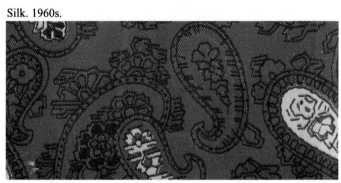

Silk. 1960s.

Silk. 1960s.

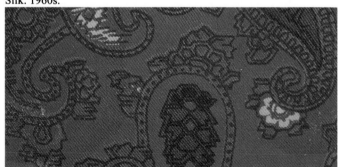

Silk. 1960s.

Silk. 1960s.

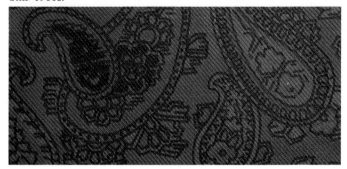

Silk. 1960s.

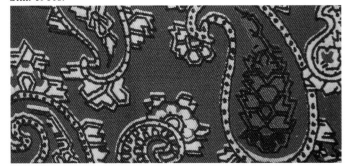

Silk. 1960s.

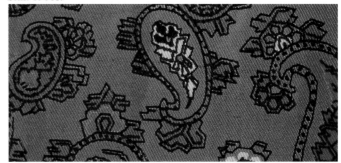

Silk. 1960s.

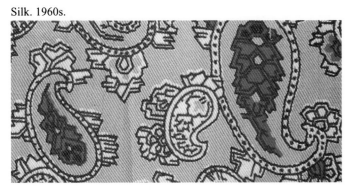

Silk. 1960s.

Silk. 1960s.

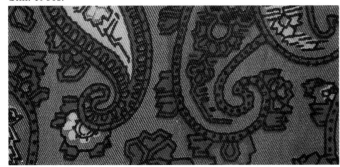

Silk. 1960s.

Silk. 1960s.

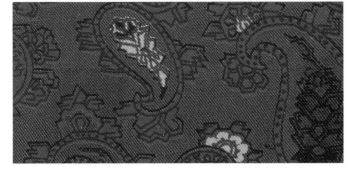

Silk. 1960s.

Silk. 1960s.

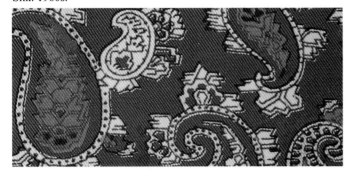

Silk. 1960s.

107

Silk. 1960s.

Silk. 1960s.

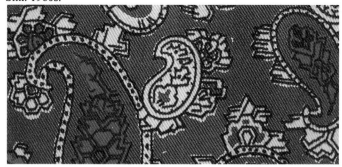

Silk. 1960s.

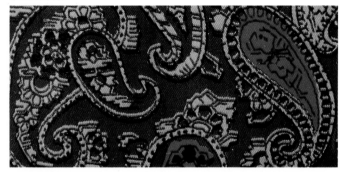

Silk. 1960s.

Silk. 1960s.

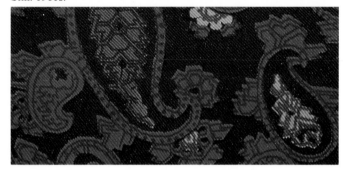

Silk. 1960s.

Silk. 1960s.

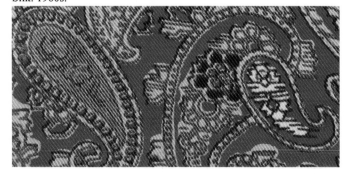

Silk. 1960s.

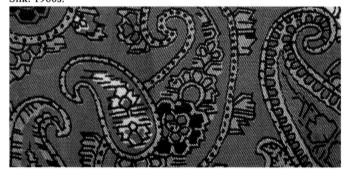

Silk. 1960s.

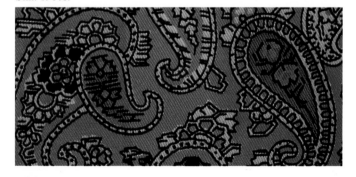

Silk. 1960s.

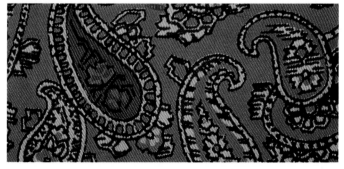

Silk. 1960s.

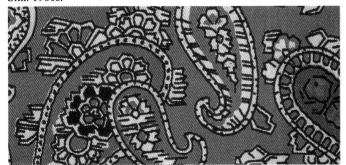

Silk. 1960s.

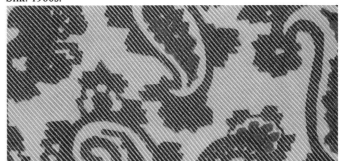

Silk. 1960s.

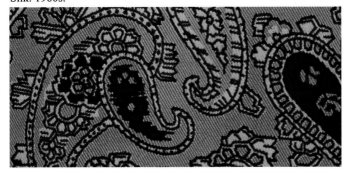

Silk. 1960s.

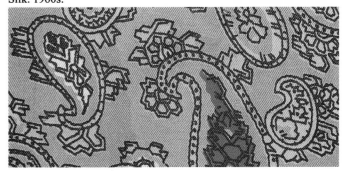

Silk. 1960s.

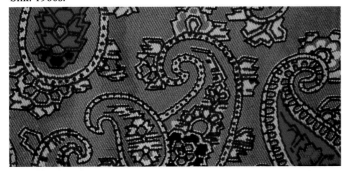

Silk. 1960s.

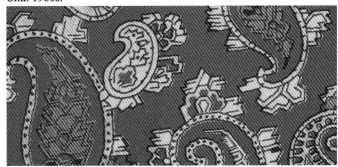

Silk. 1960s.

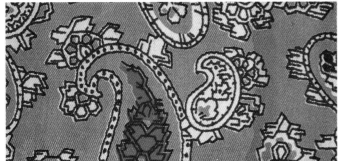

Silk. 1960s.

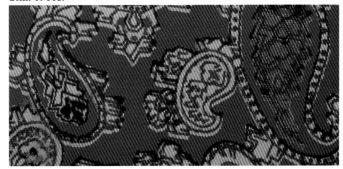

Silk. 1960s.

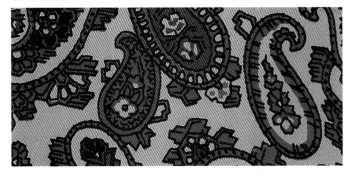

Silk. 1960s.

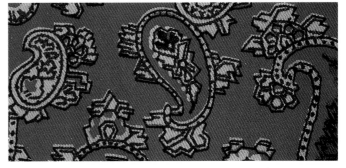

Silk. 1960s.

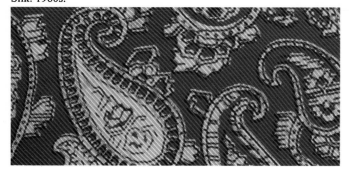

Silk. 1960s.

Silk. 1960s.

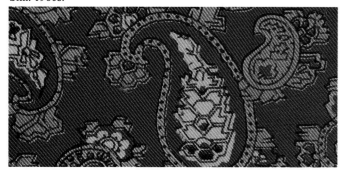

Silk. 1960s.

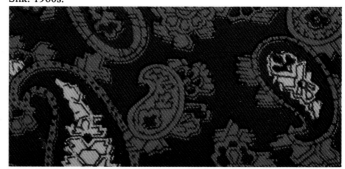

Silk. 1960s.

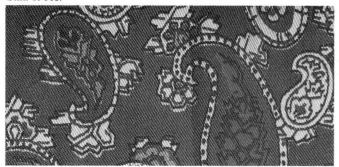

Silk. 1960s.

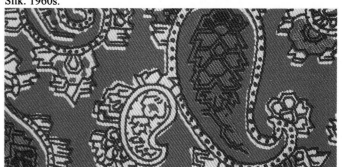

Silk. 1960s.

Silk. 1960s.

Silk. 1960s.

Silk. 1960s.

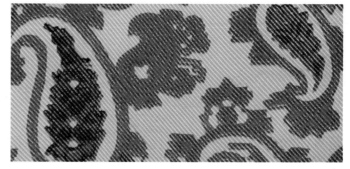

Silk. 1960s.

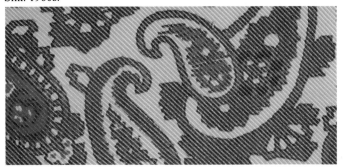

Silk. 1960s.

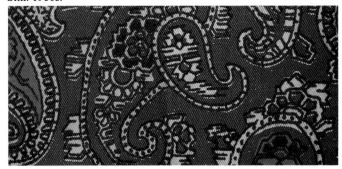

Silk. 1960s.

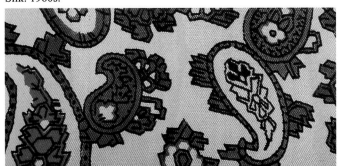

Silk. 1960s.

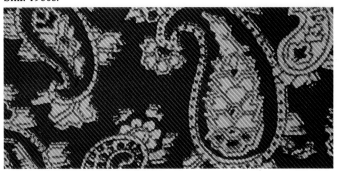

Silk. 1960s.

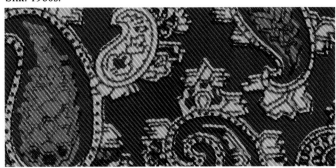

Bibliography

Jerde, Judith, *Encyclopedia of Textiles*. New York: Facts
On File, Inc., 1992.

Meller, Susan, and Joost Elffers, *Textile Designs*. New York:
Harry N. Abrams, Inc., 1991.